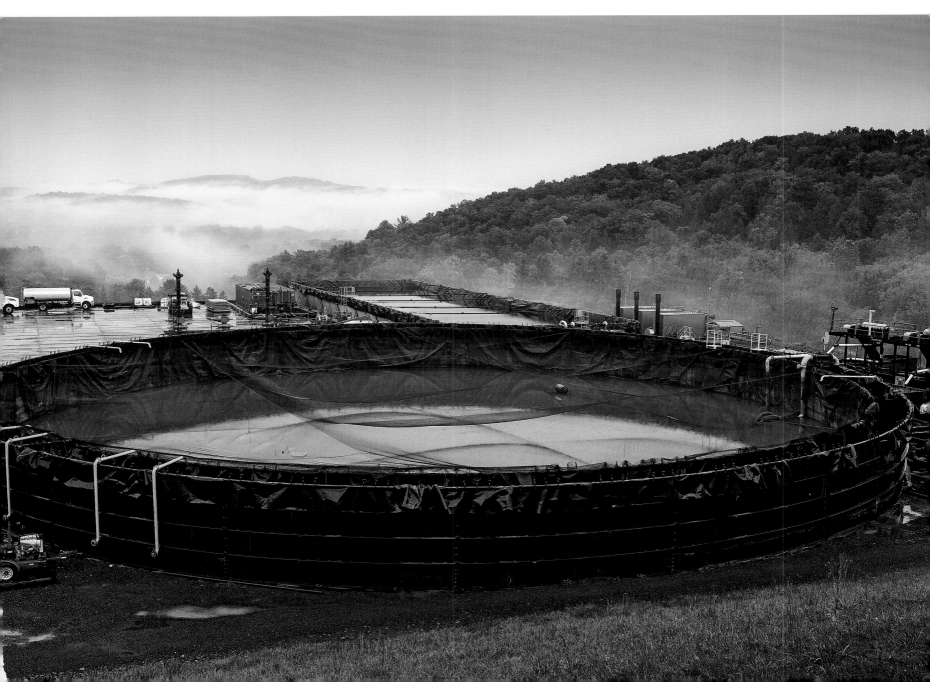

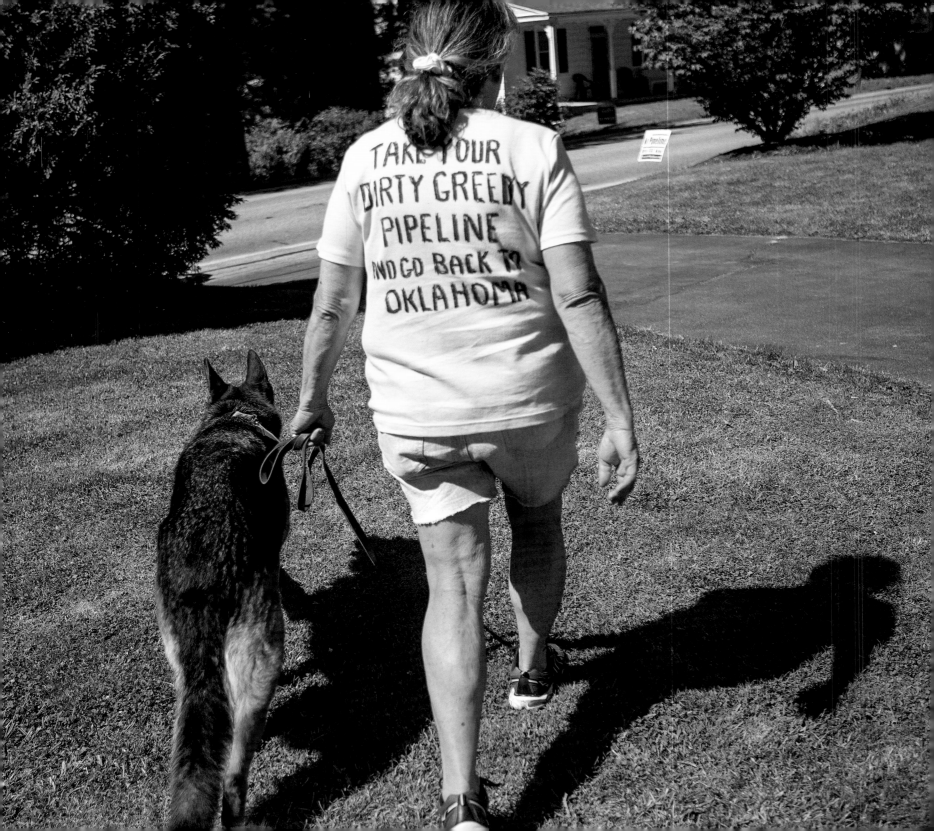

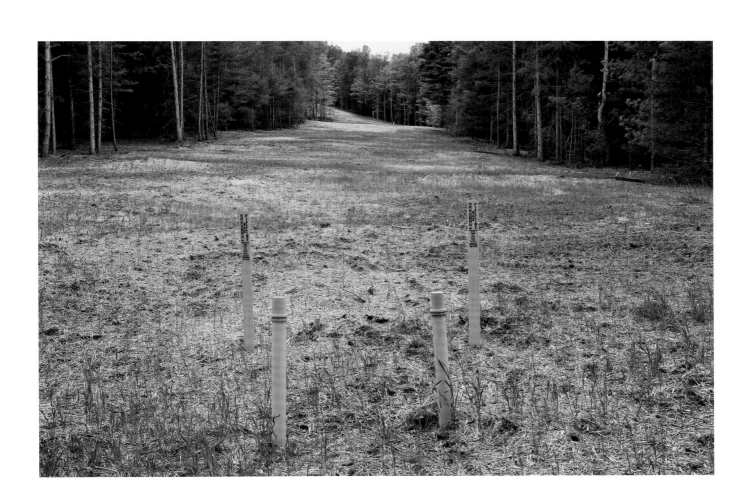

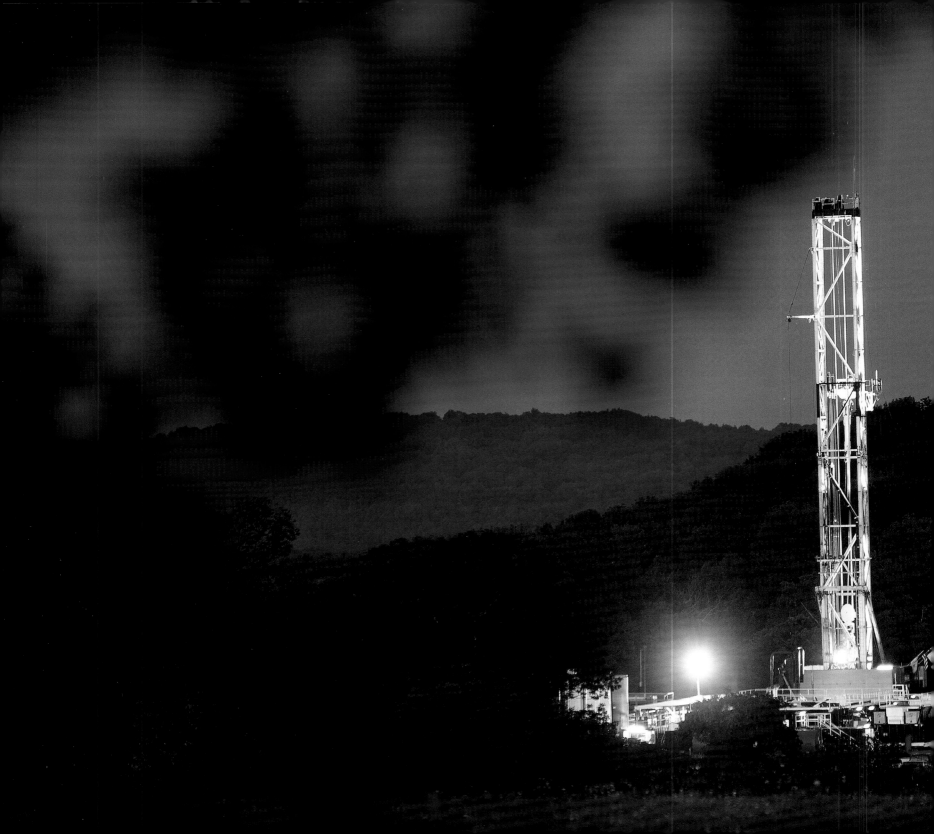

Shale Play

Poems and Photographs
from the Fracking Fields

Julia Spicher Kasdorf and Steven Rubin

The Pennsylvania State University Press

University Park, Pennsylvania

KEYSTONE BOOKS

Keystone Books are intended to serve the citizens of
Pennsylvania. They are accessible, well-researched explora-
tions into the history, culture, society, and environment of the
Keystone State as part of the Middle Atlantic region.

Library of Congress Cataloging-in-Publication Data

Names: Kasdorf, Julia, 1962– author. | Rubin, Steven,
 1957– photographer.
Title: Shale play / Julia Spicher Kasdorf and Steven Rubin.
Description: University Park, Pennsylvania : The Pennsylvania
 State University Press, [2018] | "Keystone books." |
 Includes bibliographical references and index.
Summary: "Explores, in poetry and photographs, the effects
 of the natural gas boom and fracking in the small towns,
 fields, and forests of Appalachian Pennsylvania"—
 Provided by publisher.
Identifiers: LCCN 2017054610 | ISBN 9780271080932 (cloth
 : alk. paper)
Subjects: LCSH: Gas wells—Pennsylvania—Hydraulic
 fracturing—Poetry. | Gas Wells—Hydraulic
 fracturing—Environmental aspects—Pennsylvania—
 Poetry. | Gas wells—Pennsylvania—Hydraulic
 fracturing—Pictorial works. | Gas wells—Hydraulic frac-
 turing—Environmental aspects—Pennsylvania—Pictorial
 works. | LCGFT: Poetry.

Classification: LCC PS3561.A6958 S53 2018 | DDC
 811.54—dc23
LC record available at https://lccn.loc.gov/2017054610

Published by The Pennsylvania State University Press,
University Park, PA 16802-1003

The Pennsylvania State University Press is a member of the
Association of University Presses.

It is the policy of The Pennsylvania State University Press to
use acid-free paper. Publications on uncoated stock satisfy
the minimum requirements of American National Standard
for Information Sciences—Permanence of Paper for Printed
Library Material, ANSI Z39.48–1992.

For John and Virginia Spicher
and Ted and Bunny Rubin,
who, by their loving examples,
first taught us to see the world
and listen to the voices of others.

We may feel bitterly how little our poems can do in the face of seemingly out-of-control technological power and seemingly limitless corporate greed, yet it has always been true that poetry can break isolation, show us to ourselves when we are outlawed or made invisible, remind us of beauty where no beauty seems possible, remind us of kinship where all is represented as separation.

—Adrienne Rich, introduction, *The Best American Poetry*, 1996

A socially motivated, critical practice will undoubtedly have its limits, but we have yet to approach them. As of today, when asked how much art can change society, we can answer with confidence: "Much more than it does."

—Richard Bolton, introduction, *The Contest of Meaning: Critical Histories of Photography*, 1989

Contents

Foreword *Barbara Hurd*

Three hundred million years after gas-rich rock hardened under what became the Appalachians, we humans emerged with our need to stay warm. A geologic minute later we built our well pads and horizontal drills to extract that natural gas buried deep below the surface. Then, in the nanosecond of our current now, Steven Rubin and Julia Spicher Kasdorf arrived to explore the back roads, backyards, and ordinary lives of people affected by fracking, a practice that has so divided their state of Pennsylvania for the last dozen years. In their richly layered *Shale Play*, photographer Rubin and poet Kasdorf extend the traditions of Dorothea Lange, Muriel Rukeyser, James Agee, Walker Evans, and Margaret Bourke-White into the fraught present. In these series of sketches, fragmented voices, and rural landscapes, polemics are quieted and the often buried, deep-down subtleties of our human experiences have a chance to be felt. The result is an art that shows us how a thoughtful imagination can become transformative.

Rubin has family roots in Pennsylvania; Kasdorf grew up in Westmoreland County, and I in Chester County, though I've lived a few miles south of the Pennsylvania line for more than forty years. As Maryland passed a moratorium on fracking and then finally a ban, I've kept an eye on our neighbor to the north, studied the images of crumbling roads and flaming tap water, heard the spotty stories of neighbors with sudden wealth and relief from grinding poverty. Sometimes I've felt as if I've read it all. So when *Shale Play* landed on my desk, I wondered what it could possibly add to the "I'm right, you're wrong" screech or the mind-numbing data dumps we too often call conversations about fracking.

A lot, it turns out.

Kasdorf and Rubin seem to know that, like it or not, neither logic nor plea is likely to start grassroots movements to live more sustainably. And though science-based research must provide the necessary foundation of any environmental movement, that's not what seems to move policymakers—or these artists—either. Stories, however, can and do.

Less interested in headlines than worry lines, the artists searched for patterns and coherences in disparate narrative fragments, concluding, as *Shale Play* makes clear, that it's storytelling that links complexities of relationships. By overlapping the voices of third-generation farmers tired of poverty, gas industry workers, anglers, and health officials, Kasdorf and Rubin remind us that we all live, consciously or not, within the larger contexts of other people with other stories. A many-storied life, they suggest, makes survival more possible because we just might learn to stop dismissing those whose story is not consistent with our own.

I'm heartened by news from a major workshop on global sustainability that took place in Zurich in 2016. Among the many questions that guided that think-tank effort of world-renowned scientists were these ones: "What is the nature and role of narratives (particularly around development, futures, justice, risk and disasters, conflicts) in driving human behaviour and social change, including decision-making? In what ways might these narratives influence risk mitigation and inspire transformative action towards sustainability?" (from Future Earth—Research for Global Sustainability workshop in Zurich, March 2016).

One answer to that question might be that the right narrative can do something else this book also so marvelously does: help us to see firsthand how land use changes over time. By documenting these particular places in this particular time, the artists investigate how shifts from agriculture, lumbering, and coal mining to fracking affect not just people but also the water, air, and forests that have long sustained them. Living as if there is no past can be as shortsighted as living as if there is no future. Stories of the land itself—its environmental history—can help us grasp that even the most stationary among us live in many places at once, from backyard local to geologic global. Perhaps with such broader views, the book suggests, we can begin to make sound decisions about how things hold together and what can tear them apart.

In the poem "Sacrifice Zone, Tioga County, PA," Kasdorf cites Muriel Rukeyser's *Book of the Dead*. Rukeyser wrote about the silicosis outbreak that resulted from a tunnel excavation, part of a hydroelectric project in West Virginia in 1931. Inhaling silica dust without masks or other safety measures, hundreds—maybe thousands—of men died.

By referencing that earlier tragedy, Kasdorf positions *Shale Play* in the history of literature about industrial tragedies—the BP oil spill, the Three Mile Island accident, the Georgia sugar refinery explosion—that will likely continue. And though both Kasdorf and Rubin evoke the voices of all kinds of people caught up in the fracking wars, they also have their eyes on something less dramatic than fatal explosions, something bigger and more insidious: the disruption of whole ecological systems, most of which have survived for hundreds of years through the slow evolution of delicate balances. Add to that disruption the alteration of whole social systems, which so often triggers violence against peoples whose voices have traditionally been muted. The frenzied pace of the fracking boom and its sweeping effects, they imply, threaten to dwarf those earlier tragedies.

How do Kasdorf and Rubin do this?

She writes poems with titles such as "September Melon, Seismic Testing," "Sealed Record," and "What This Picture Can't Tell You." Some are spoken in the voices of those affected: of a man whose childhood playground was the whole of these unfracked mountains, a grandmother, a trucker, a pastor, ordinary citizens, like most of us, who drive cars and heat our homes, complicit citizens, like most of us, who struggle to get the big picture.

He takes photographs on farms, at hearings, and of compressor stations, protestors, and gas workers.

The two of them stand on small porches, enter kitchens and backyards, sit down at local diners, approach drill pads, crisscross the counties. In other words, they take a line from Rukeyser to heart: "These are the roads to take when you think of your country."

More than 20 percent of the photos in this collection, in fact, are of roads. Rubin shows us roads a kid in the country might have once biked down, rural roads now lined with *Heavy Truck Traffic* signs, roads with construction workers in neon vests carrying bright orange *SLOW* warnings, and some with citizens in sneakers carrying *NO* signs.

One image focuses our eye on four water trucks that take up more than half the width of the road.

The drivers' faces are obscured; the giant grilles—like three-foot-high metal teeth—are not. They lumber toward us.

And then there's the road we can barely see, on which a gas truck approaches. In the foreground, the control valve of a gas pipeline resembles a giant faucet rammed into the field of black-eyed Susans.

The point is that to alter roads in a rural county is to alter its residents' orientation to place. As one speaker in a poem says, "They close roads for our safety, roads we used all our lives, / and they put up security booths. Imagine needing security / on Okome Mountain!"

As I turn the pages, I am transported from roadside diner to forest, from intimate to vast. I go down one road and then another, which becomes a different road now because the poet and photographer are teaching me how to see this landscape and the everyday lives of individuals who live here. Thus the book, like all good art, prompts philosophical inquiries. Who are we in relation to the world we live in? Which world? And who is "we"?

In one of the poems, a trucker wonders what will be left for his grandchildren.

In another, a pastor says, "Oh, I've got plenty / to keep me on my knees."

But there are also state-of-the-art tractors, repainted houses, and the new handicapped restrooms on the old Sheepskin Trail. And as one enthusiastic diner asks, "Who wouldn't . . . take a table with a view / of helicopters dangling the pendants of seismic testing?"

In one photograph, Rubin shows us bright-white plumes against a brilliant-blue sky and in another a water pipe sinewing alongside a rural road with all the flowing bend and grace of a fallen Giacometti. Both suggest the combination of crudeness and elegance that so often marks the lurching progress of human ingenuity as we try to keep ourselves warm, nourished, and safe.

Isn't there anything to admire in all that?

Of course there is, but every photograph suggesting marvel is soon followed by one suggesting despair. Turn the page, Rubin and Kasdorf urge, and there, next to the serenity of a country lane, is a breathing mask hung from a rearview window. No applause, the artists seem to say, for a vision that narrows or hoards, discounts or lies. No admiration without taking into account the cost to people's lives.

Rubin and Kasdorf have avoided the danger of conflating truth and ideology by creating a collage of lyric voices, dramatic monologues, reportage, and testimony. The polyvocal nature of *Shale Play* means no voice dominates. Indeed, the dramatic tensions—finely held—in this book arise equally out of the harsh pressures of marginalized lives, conflicts with industry and government groups, and the disconnect between any of our daily lives and a broader sense of time.

Barry Lopez says that the "environmental crisis is no such thing: it is not a crisis of our environs and surroundings; it is a crisis of our lives as individuals, as family members, as community members, and as citizens." *Shale Play* shows us that reimagining our roles in these crises is one way to avoid hardening into dogma, to start reforming our responses to one another and to the places we call home.

One of the most striking images Rubin offers captures a roadside sign that reads, "Expect Long Delays." Perhaps that's exactly what, in fact, we should hope for—a delay in the pace of drilling, a chance to absorb a book like *Shale Play*. It is, as poet Robert Frost suggests, what art can offer—a "momentary stay against confusion," a pause to consider the larger picture.

The Appalachians continue to erode. A thousand years from now, who knows what will happen to

abandoned mine shafts forced open by fracking? Who knows what human ingenuity will have arrived by then to devise new ways to stay warm, to travel, to fuel whatever advances are next? But the future is not just something that lies ahead into which we merely stumble. Nor is it a clear road whose trajectory we can pretend to see. The future to which we keep on arriving is always an amalgam of our past mistakes, our missteps, our triumphs, and the complicating impulses of the human heart—which means artists will arrive there, too, doomed and blessed to help us see that what we do affects who we are.

What enormous good fortune for us that Kasdorf and Rubin have arrived here and now to be our guides on both literal and figurative roads through the landscape of *Shale Play*. Though this stunning book is full of reasons to be scared, it is less concerned with the arguments many have made for or against fracking and more concerned with listening to the many who are—subtly or dramatically—affected.

Maybe such listening will sway the legislators and regulators in Pennsylvania to rethink their policies on fracking. Maybe citizens will do as we've done in Maryland and lobby for a ban. Maybe not. But if nothing else, readers will finish *Shale Play* more deeply aware of the resonance of places named "Hope Hollow Road," more disquieted by the possibility that these artists have alerted us—artfully, astutely, and uncomfortably—to a looming and critical fork in that road.

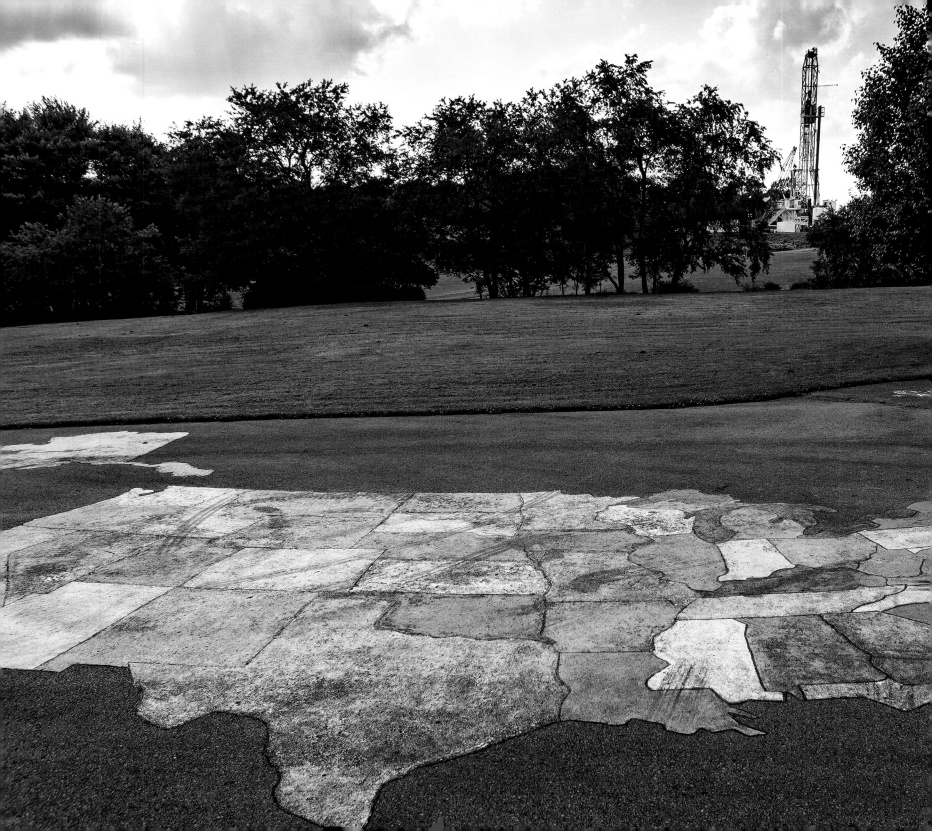

Preface

We would like to think that these pictures and poems need no introduction. Maybe every artist who attempts to faithfully render what he or she sees in the world aspires to that kind of immediacy. Indeed, you could easily flip past these pages and go straight to the photographs and poems. Beyond capturing beauty or destruction, beyond the evocation of feeling, however, these images and texts can also function as a document of particular times and places, and therefore they require additional explanation.

This book was created during the years between 2012 and 2017 in the play that followed the rush to develop the Marcellus Shale in Pennsylvania. The Marcellus cuts a wide, diagonal swath across Pennsylvania from New York to Maryland, West Virginia, and eastern Ohio. It is the largest natural gas discovery in the United States and, as far as we know, the second largest in the world, after one that straddles Iran and Iraq. In the language of the industry, *shale play* refers to a commercially exploited region—both geographic and geological, above and below the earth's surface—containing petroleum or natural gas accumulated in sedimentary rock.

The phrase suggests many other things, of course. Think of the scramble of landmen who drive out remote country roads to knock on doors of farmhouses and trailer homes, eager to press lease contracts into the hands of property owners. Consider the constant negotiations in Harrisburg, where a state legislature, flush with campaign contributions from oil and gas companies, struggles to formulate regulations and fair tax codes for unconventional drilling more than a decade after the boom began. Hear the back and forth of complaints and placations at public meetings of township supervisors and zoning boards. Finally, listen to the cast of human voices—some guarded, some work weary, some delighted with unexpected wealth, business, or employment opportunities, and some so exasperated they can't stop talking about what has happened since that well or pipeline or compressor station was built near their homes.

According to *The Boom*, Russell Gold's comprehensive history of hydraulic fracturing (fracking), the first fracker was Edward Roberts, a Civil War veteran who got the idea from watching shells explode underwater in the Battle of Fredericksburg and used torpedoes to blast cracks in the rock

around spent oil wells in Titusville, Pennsylvania. Before 1901, northern Pennsylvania—then north-western Ohio—launched the American oil industry. Throughout the twentieth century, attempts to increase productivity led drillers to put hydrochloric acid, nitroglycerine, napalm, and even nuclear bombs into wells. In the 1990s, pioneers in the Barnett Shale in Texas developed the complex industrial process that involves drilling more than a mile below the earth's surface, then horizontally along the layers of the sedimentary rock for two miles or more, the drill bit drawn to radioactive material that marks the rich shale formation. Explosives are detonated in the bore hole to fracture surrounding rock. Then, between four and seven million gallons of "slick water" (mostly water but also chemicals and sand) are forced into the hole at more than nine thousand pounds of pressure per square inch. Thus, the shale is fractured, and the gas it contains flows up under its own force.

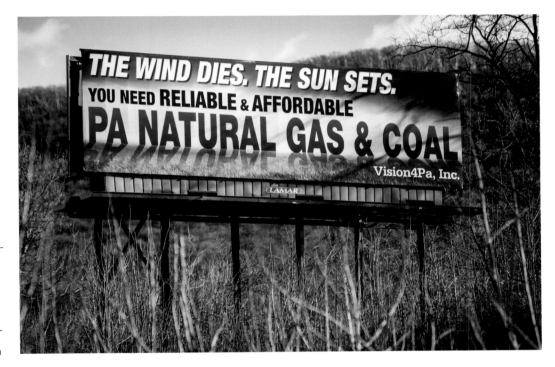

In Pennsylvania, Range Resources Corporation began experimenting with fracking in Washington County early in this millennium, drilling the first successful nontraditional gas well there in November 2004. By 2006, Cabot Oil and Gas Corporation began the operations in Susquehanna County that since have become synonymous with failed cement casings, methane migration, exploding waterwells, and flaming faucets. In 2008, Penn State geoscientist Terry Engelder announced his calculations of the vast extent of the Marcellus Shale formation, launching a land rush. A number of companies deployed armies of landmen (and a few women) to lease or secure gas rights on private and public property in the competition to dominate the play.

The metaphors of military invasion and images of assault on the earth have not been lost on some observers.

According to the U.S. Energy Information Service, a government agency, natural gas represented one-third of all energy produced in the United States in 2016, and the largest source of electrical generation. For the fourth consecutive

year, Pennsylvania ranked behind only Texas in natural gas production. Surplus supplies have depressed prices and slowed development somewhat in the northern counties, but drilling continues in southwestern Pennsylvania, in part because methane in that area also contains valuable by-products such as ethane and butane, which are used in the production of plastics. Although 2016 saw some industry layoffs, we still see pipeline crews—often staffed with workers from far away—deployed throughout the Commonwealth; every four hundred feet of pipe they lay clears an acre of forest. Amid bitter eminent domain battles, crews seek to lay pipes to transport liquid natural gas by-products eastward across the southern length of the state to the port at Marcus Hook, where ships have already begun hauling cargo to petrochemical companies in Europe. In the northeastern part of the state, citizens' groups have halted natural gas pipeline completion. What we see now represents less than 10 percent of the expected development of the Marcellus Shale Play in Pennsylvania.

This book seeks to make visible some people and places as they have experienced the shale play in four Pennsylvania counties: Tioga and Lycoming in the north-central part of the state, and Westmoreland and Fayette in the southwest.

Currently, Bradford and Susquehanna Counties in the north, and Washington and Greene Counties in the southwest count more active Marcellus gas wells, but the four counties considered in this project fall next on the list. These are mostly rural places with working populations who have experienced job loss and outmigration in recent decades. Apart from a few deep coal mines, a handful of oil wells along Pine Creek in the nineteenth century, and shallow gas wells in the 1930s, north-central Pennsylvania has been largely an agricultural and lumbering region, as well as a tourist destination. Over 70 percent of the votes in those counties went to Donald Trump in the 2016 election; Tioga County, 74.6 percent. By contrast, southwestern Pennsylvania is more densely populated. Once devoted to the production of coal, coke, and steel, and the labor movements that accompanied those industries, it also increasingly serves as a distant suburb for Pittsburgh. Just over 64 percent of the voters in the two southwestern counties chose Trump.

Maybe the least interesting thing that can be said about a place is whether it went red or blue in the 2016 election.

More meaningful may be the fact that in Pennsylvania, unlike in Texas, fracking does not take place in the richest parts of the

Commonwealth. Some wealth concentrates in small suburban communities near the city of Pittsburgh, which has banned fracking, and near Harrisburg. By far, however, the state's greatest wealth lies in the four counties in southeastern Pennsylvania, which belong to the suburban corridor stretching between the Washington, D.C., area and New Hampshire, a region that will consume the bulk of fracked gas produced by the Marcellus Shale. As with coal mining during the last century, resources from the interior fuel the eastern seaboard; one part already bears the environmental cost and public health risks of carbon extraction, while the other enjoys cheap heat and light, and reaps the profits. Drilling is currently prohibited in the counties along the Delaware River Basin due to a 1961 compact signed by President Kennedy and the governors of New York, New Jersey, and Delaware to protect the Delaware River, which provides drinking water for about fifteen million people. Both industry interests and some landowners are now battling the de facto moratorium in hopes of drilling the Marcellus Shale in eastern Pennsylvania.

In Pennsylvania, nuclear power supplies 39 percent of the state's electricity, but natural gas has eclipsed coal as a source of electricity generation, according to the U.S. Energy Information

Service. Meanwhile, a report from *Bloomberg New Energy Finance* recently predicted that by 2040, zero-emission energy sources, such as sun and wind, will make up more than one-third of power generation around the world. A similar report by the International Energy Agency predicted that by 2030, renewable sources of energy will replace coal as the world's greatest power source. For the year 2015, Denmark met 42 percent of its energy consumption from wind, the highest percentage of any country in the world, according to Forbes contributor Robert Rapier.

As lower production costs gradually turn the global energy market to sustainable sources, carbon emissions that contribute to devastating climate change will decrease. Gas, once heralded by President Barack Obama as the "bridge fuel," has been proven to hasten climate change primarily due to methane leaks and the consumption of fossil fuels essential for natural gas production. For the next few decades, however, it looks as if the oil and gas industry in Pennsylvania, if unchecked, will continue to lay pipelines and industrialize farmland and forests with trucks and diesel-driven drills and generators.

To our north, New York State has banned fracking, as has Maryland to our south. In Pennsylvania, our collective memory of previous extraction

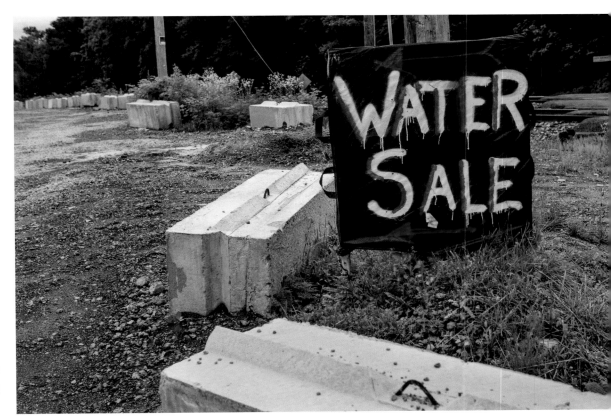

booms—iron, lumber, oil and gas, and especially coal—shapes our experience of this boom, but differently. Some see carbon fuel as merely another product we produce in the middle of Pennsylvania. Others point to streams that remain poisoned with acid mine drainage, to degraded landscapes that still wait to be restored at taxpayers' expense, and to new crews working at dangerous jobs without adequate protection, and cry, "Not again!"

What causes some people to tolerate and others to resist an abusive situation?

At an art gallery in Wellsboro, Tioga County, after a lecture given in conjunction with an exhibit of Steven's photographs last winter, a local man stood up. He regretted having leased his land to the "liars" in the gas industry, and he had recently been down to Penn State, where he saw the new ice hockey arena that bears the name of Terrence Pegula. An alumnus and $102 million donor to the university, Pegula was the founder of East Resources, which had amassed, then sold to Royal Dutch Shell, mineral rights for fracking in Pennsylvania, New York, and the Rocky Mountains.

"I see they haven't put up a sign outside that arena thanking the citizens of Tioga County yet!" the man exclaimed.

While it is true that some people have received significant wealth in royalties by leasing their land, and some have gotten work, it is also true that such gains have come at great risk and cost to our local places and global climate.

Consider this book an opportunity to meet a few of the invisible citizens living amid the changes brought about by shale gas development in our Commonwealth. Lean in and listen to human voices behind the easy caricatures of the white working class. Look at particularities that underlie the false opposition that pits those who are pro-jobs and pro-energy against those who are pro-environment, and recognize that jobs and energy do not need to be gained at the expense of the environment—unless Marcellus drilling is the only option we consider. See the ways memory and attachment to place can sustain resilience and a determination to work for justice. As you read these words and view these images, imagine some places and people who already live every day in the midst of the shale play.

Julia Spicher Kasdorf, Poet

A twenty-four-inch interstate transmission pipeline was laid through a farmer's field and over a forested ridge about a mile from my house in 2009, and around that time, my hometown of Bellefonte sold water from the Big Spring—our only source of drinking water—for fracking. So close, and yet I hadn't grasped the impact of shale gas development then. I didn't notice that a large compressor station had been built in an out-of-the-way farmer's field in Pleasant Gap, three miles from my home, or that a transmodal operation was established at a nearby quarry to supply gravel, silica sand, and other necessities to drilling operations upstate. This is how hard it can be to see the workings of this complex, transient, far-flung industry.

Not until the summer of 2012, riding pillion on a motorcycle up Route 15 at Steam Valley Mountain in Lycoming County, did I see it: pieces of pipe arranged along a trough dug into the hillside, a cluster of white pickups, helicopters circling overhead, and in the parking lot of Fry Brothers Turkey Ranch, so many pneumatic bulk tankers! None of it made sense, which startled me because I take pride in recognizing what I'm looking at in Pennsylvania. In the past, driving up that road, I would have thought of oxen and Conestoga wagons of Mennonite farmers from Lancaster plying the trail to Ontario after the American Revolution or the old road between Williamsport and Rochester a century later, steam-powered sawmills at work on the ridge amid shambles of clear-cut forests. But what was this?

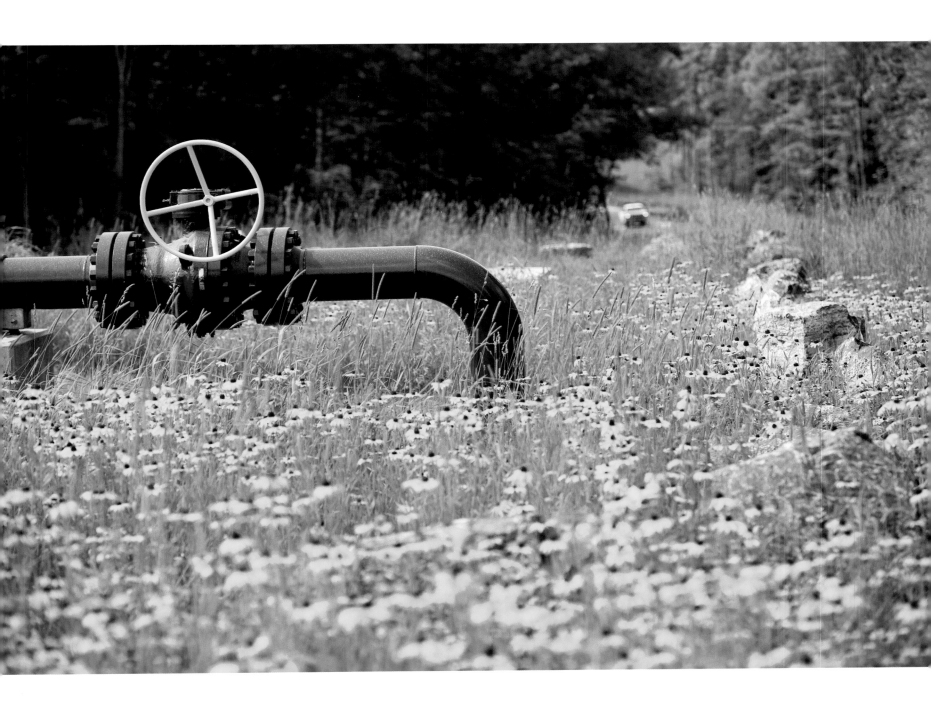

to and document the experiences of individuals encountering them firsthand.

In the spring of 2013, I visited Mansfield University, and later that summer returned to Wellsboro and the home of Judith Sornberger, where I stayed for a week so I could explore Tioga County and spend time with local environmental writers Jimmy and Lilace Mellin Guignard. The subsequent fall and spring, on sabbatical with support from Penn State's College of Liberal Arts and Institute for Arts and Humanities, I made numerous trips to two regions of the state: north-central and southwest. I chose those places because I was familiar with their people and environments, and because they had distinctly different extraction histories. I grew up in Westmoreland County during the 1970s, when steel mills started closing along the rivers in Pittsburgh. Surface mining operations and slag heaps, abandoned coke ovens, and coal patch towns were just familiar parts of the industrialized, rural landscape I called home.

With this project, I returned to those places with purpose, opened my laptop in the Pennsylvania Rooms of public libraries and in the Coal and Coke Heritage Center on Penn State's Fayette campus. I talked to people in diners, attended public meetings, and scribbled a lot in

Waitresses at the restaurant explained that the activities and machines belonged to the natural gas industry, which was mainly welcome in that rural community. On the way home, descending the same mountain on Route 184, I saw orange signs warning of seismic testing. Further on, an open liquid impoundment stood next to a house and barn. With cousins still working on dairy and produce farms in central Pennsylvania, I appreciate the difficulty of making a living on the land and the need for some people to find new opportunities in rural places. So, confusion and curiosity drove me to investigate the geology, engineering, economics, politics, and local impacts of shale gas development—and to listen

my notebooks. Jim Rosenberg and the Fayette Marcellus Watch group welcomed me to their monthly meetings at chain restaurants on the strip outside Uniontown, and I visited the homes of some of the group's members. Typically, I told people I wanted to write about fracking and asked if I could transcribe their experiences in their own words. After I crafted a monologue, when possible I returned to read it to the speaker to see if I had captured his or her words accurately. Invariably, when people spoke of their encounters with the gas industry, they traced relationships with the land and alluded to the history of the place. Those perspectives increasingly guided my inquiry.

"Pennsylvania sold its soul around the time of the Civil War. We were owned by the coal industry," explained a woman descended from coal miners in the southwestern part of the state. "We are not completely owned by the gas industry now, but they don't know us. They know nothing about who we are or what happened here before." Wealth made in Fayette County always ends up elsewhere, she explained (e.g., the Frick Collection in New York), but what of the landscape and people left behind?

Wanting to learn what happened in Pennsylvania, I showed up and listened like Muriel Rukeyser in 1936 investigating the Hawks Nest Tunnel disaster, and I also wrote from research and found texts or transcripts, as poet Charles Reznikoff once worked from court testimonies. I believe that poetry is our best strategy for accessing memory and feeling. The imagination is our sharpest tool for making meaning from overwhelming emotional experiences, our shortest path to finding empathy for others or envisioning real change. Unlike the personal narratives and lyric poems I had previously published, however, this work strained beneath its documentary freight, and I wondered whether these poems would finally need photographs to succeed. So I was grateful to meet documentary photographer Steven Rubin, who was already at work on a similar project.

What began with a jolt of curiosity about industrial activity in a rural place has led me to learn about the enormous and complex process that is fracking, and to think more deeply about local history, community memory, public health, and economic inequity. I am thankful to have reason to return to the counties southeast of Pittsburgh, where I spent most of my childhood, to follow the back roads I used to drive as a teenager. Personal memory also serves as evidence in these documentary pieces. A few of the shorter poems are spoken in my own voice, and the final poem casts me in the place of one of my subjects as a "citizen with too much memory" who cannot help but see violence in the landscape she loves.

Steven Rubin, Photographer

Before becoming a professor, I worked as a documentary photographer and photojournalist, covering national and international issues for a variety of media publications and nongovernmental organizations. In pursuit of stories across the country and around the globe, I traveled to photograph topics such as democratic reform movements in Chile, Burmese Chin refugees in northeast India, and the U.S. government's detention of immigrants and asylum seekers. An interest in environmental issues led me to document the effects of oil exploration on indigenous communities in the Ecuadoran Amazon and to examine the rise and impact of wind farms in the Midwest. I was not accustomed to looking in my own backyard for subjects, however, until unconventional drilling techniques directed my focus close to my State College home.

In the summer of 2012, enticed by news reports and widespread claims about Pennsylvania's natural gas boom, I began driving the conspicuously

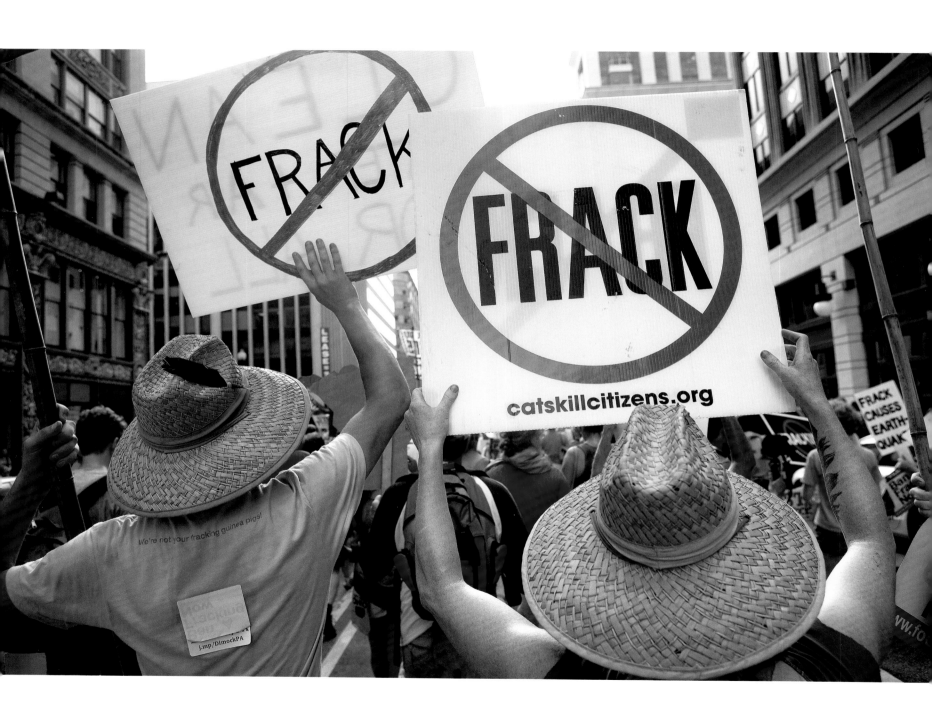

widened and reinforced roads of Moshannon State Forest in nearby Clearfield County to take a closer look. On public forestland, I encountered convoys of trucks carrying sand or water and tankers benignly labeled "residual waste." Following those trucks, I discovered brilliantly illuminated drilling rigs, well pads, pipelines, and other pieces of infrastructure transforming woods and farmland into industrial sites. The trucks also led me to workers, many of whom were quite reluctant to be photographed or even speak with a stranger until they were certain I was not one of those eco-terrorists they had been warned about. Drawn especially to the people who sought oil and gas jobs in a region desperate for decent employment opportunities, I began to photograph workers on location, as well as community college students training for jobs in the gas industry.

On the other side of the political and social divide, I started documenting anti-fracking protests, beginning with the Stop the Frack Attack rally and march in Washington, D.C., in July 2012, which drew thousands of activists to the nation's capital to oppose fracking and to demand greater government regulation and corporate accountability. At subsequent protests, I met activists and organizations, such as Barb Jarmoska of the Responsible

Drilling Alliance in Lycoming County, who introduced me to people who have endured nightmarish experiences as a consequence of shale gas drilling in Pennsylvania. As different as these experiences were from the hopes that most workers expressed, they also became subjects for my documentary lens. Thus, I began examining and representing not just the disturbances in the physical landscape but also differences in the way shale gas development is understood and experienced by people across the state.

As a photojournalist, I was drawn to the hyphenated space where image meets text to establish a meaningful hybrid. Working in a different capacity now, I remain attuned to the possibilities that emerge at the point where pictures and language connect. I am fascinated by the human proclivity to look at photographs and feel compelled to voice a response to them, as well as by the mind's tendency to create mental images while reading or listening to evocative descriptions. Photography inherently aestheticizes its subjects, and yet a photograph becomes more than a beautiful object when accompanying text establishes its context in time, place, and social history. While a single photograph can only ever capture a momentary, discontinuous sliver of life, language offers the possibility of

expanding the moment and unfolding larger, more involved stories over time.

Coming to understand some of the complexity of the Marcellus Shale story, I felt concerned that if my images from this project were to be shown outside of a journalistic context, or devoid of any kind of meaningful writing, they would remain free-floating aesthetic objects, untethered from the vital but invisible details lying beyond the lens' vista. Worried that these details and layers would go missing with only stand-alone photographs, I felt a stroke of good fortune when I met poet Julia Spicher Kasdorf at a meeting of the Shale Gas Ethics Interest Group at Penn State. The discussions and collaboration that ensued, leading to this book and the creation of a series of joint exhibitions and presentations, seemed to offer an ideal tether to ground the photographs while also extending their reach.

As part of my own investigation, I photographed the Pennsylvania Jobs, Pennsylvania Energy rally in May 2014, an industry sponsored pro-drilling demonstration in Harrisburg that brought several thousand workers and backers from across the state to champion the benefits that shale development has brought to the Commonwealth. This event also showcased an ongoing publicity and lobbying

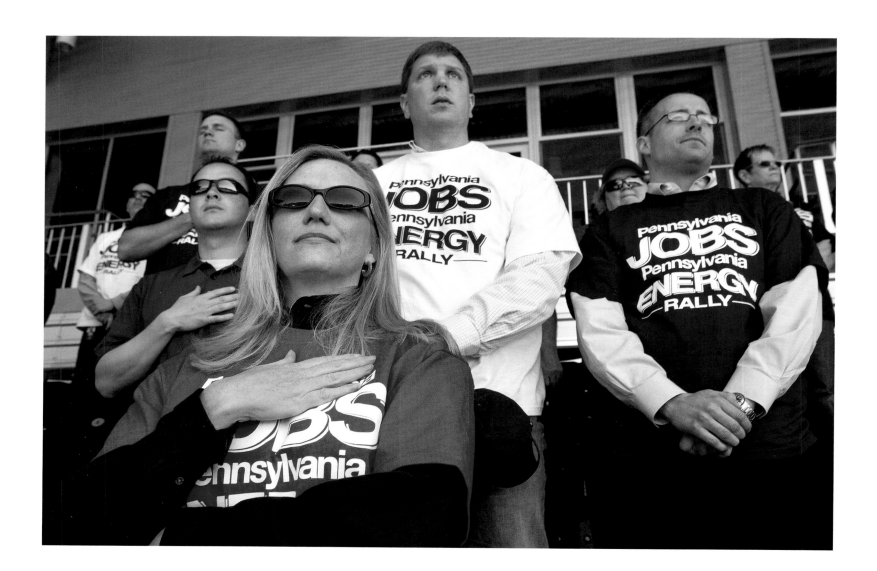

campaign to oppose the establishment of a sever-ance tax—a fee charged on gas as it is drawn from the ground—which funds industrial oversight in states such as Texas, Oklahoma, and West Virginia. Pennsylvania remains the *only* natural gas-produc-ing state in the nation that does not impose such a tax on unconventional gas drilling. As I tracked these developments, I could easily see the powerful and frequently disproportionate influence gas companies exercise over government, whether at the local, state, or federal level.

The advantages enjoyed by the industry are not limited to a close association with government but also extend to academia, where corporate funding often determines engineering and geology research agendas. In 2009, two professors affili-ated with Penn State inflated the size of potential economic gains to be gotten from gas drilling and advised against a severance tax—while remaining quiet about receiving industry funding themselves. This apparent collusion between government, academia, and corporate interests shapes public perceptions and drives mistrust, especially among anti-fracking activists, whose wariness about Penn State I encountered frequently in my fieldwork.

Affiliation with a research university did not account for all the wariness I met as I worked on this project. Although the subjects of *Shale Play* live much closer to me, I often found photo-graphing people in their own settings to be more challenging in Pennsylvania than elsewhere in the world. I typically enter remote places and photo-graph people unposed in their own environments, whether through my project "Vacationland," which documents a decades-long relationship with a com-munity in backwoods Maine, or a briefer immersion among Burmese Chin refugees and migrants living near the border dividing Burma and Mizoram State, India. In rural Pennsylvania, however, my subjects expressed reluctance to be photographed for many good reasons. Those who work for large gas companies are often forbidden from talking to the media, and they risk losing their jobs for doing so. Those who have benefitted from wells on their land are sensitive about monetary gain in places where their neighbors struggle with economic hardship. Those who have been harmed and are now pursuing legal remedies and negotiations with gas companies must avoid publicity for fear it will jeopardize their legal cases. Those who have

reached settlements with the companies are bound by nondisclosure agreements. Some people are simply reluctant to be represented in relation to an issue that has become so divisive in their own com-munities and even families. For all of these reasons, Julia and I deeply appreciate the risks people have taken to share their experiences in these images and words, and for the countless ways they have generously assisted us.

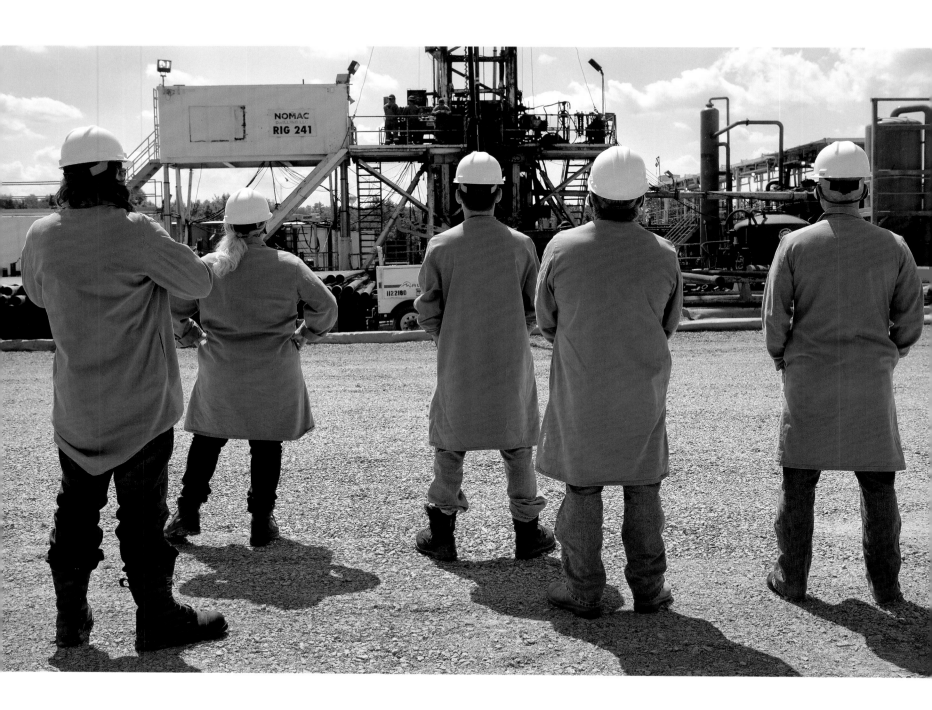

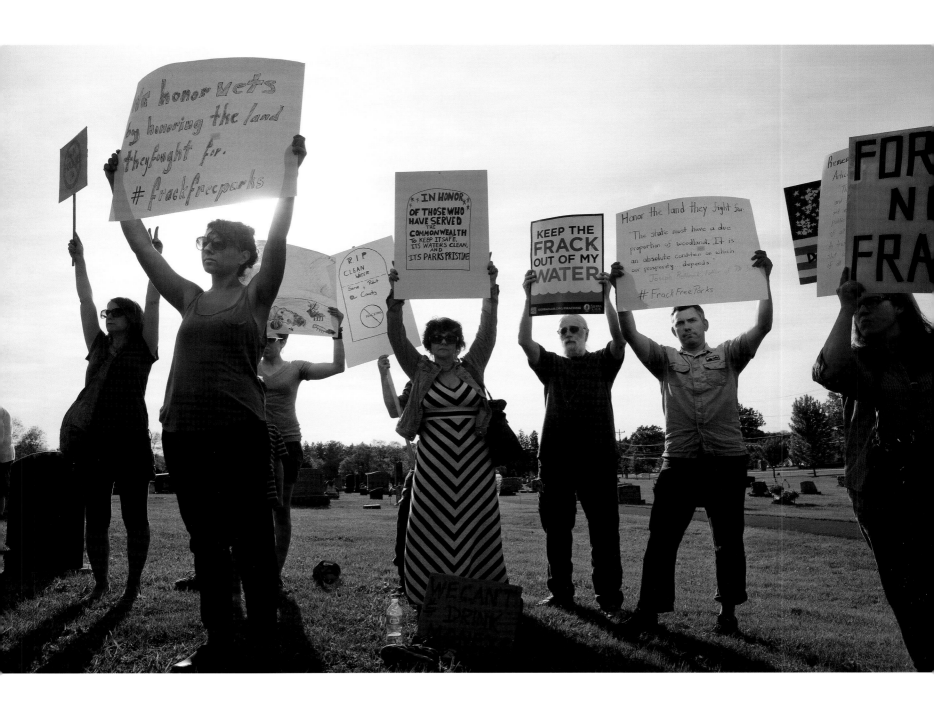

Acknowledgments

Among those we would like to thank for their faith in this project and for their help in large and small ways are Jim Rosenberg of Fayette Marcellus Watch; Duane Nichols of Frack Check WV; Barb Jarmoska of the Responsible Drilling Alliance; Joshua Pribanic and Melissa Troutman of *Public Herald*; Michael Badges-Canning of Marcellus Outreach Butler; Kathryn Hilton, Stephanie Novak, and Jordan Hoover at Mountain Watershed Association; Frank Varano in Lycoming County; Bob Deering in the Tiadaghton State Forest; Dee Calhoun along Pine Creek; in Tioga County, John Kesich, Jimmy and Lilace Mellin Guignard, Judith Sornberger, and Mike Chester at the Always Something Farm; Anna Wales with the Gmeiner Art and Cultural Center in Wellsboro; Steve Getz and Carol Cillo at the Station Gallery in Lock Haven; and Kayleb Candrilli from Wyoming County.

In southwestern Pennsylvania, we thank Betty Pahula (1935–2017), as well as Evelyn Hovanec, Elaine DeFrank, and Julie Porterfield at the Coal and Coke Heritage Center, and Bill Jackson, J. Lorne Peachey, and Scottdale attorney James Lederach. Additionally, special appreciation to those who maintain activist conversations and actions near Uniontown, including Phyllis Carr and her family, Stan and Jean Burns, John Ryeczek, Mary Grace Butella, Crystal Franks, and others we could not name.

For help in understanding labor and training matters, we thank Rex Moore at ShaleTEC; David Pistner and Byron Kohut at Westmoreland County Community College's Advanced Technology Center; and Bob Payne at Pennsylvania General Energy Company.

We appreciate the expertise and assistance shared by members of the Penn State community, including graduate student Arielle Hesse and faculty members Mike Arthur, Kathleen Brazier, Timothy Kelsey, Lara Fowler, Kai Shafft, and Leland Glenna; Bill Doan, director of the School of Theatre, and Michael Bérubé, director of the Institute for the Arts and Humanities; Peter Buckland and Denice Wardrop of the Sustainability Institute; Dave Yoxtheimer of the Marcellus Center for Outreach and Research; Dana Carlisle Kletchka and Joyce Robinson at the Palmer Museum of Art; Graeme Sullivan, director of the School of Visual Arts; Andrew Schulz, dean for research in the College of Arts and Architecture; Eric Silver, associate dean for research and graduate studies in the College of the Liberal Arts; Mark Morrisson, head of the Department of English; and the College of Arts and Architecture and the College of Liberal Arts. This publication was made possible through a generous subvention from the James E. Hess and Suzanne Scurfield Hess Research Endowment in the College of Arts and Architecture, as well as subvention assistance from The Institute for Arts and Humanities, the Department of English, and the College of Liberal Arts.

Nicole Cooley read many drafts of these poems and offered valuable critique, and Danielle Ryle applied her pitch-perfect eyes and ears to the final typescript. We also thank the editors of the following journals, in which some of these poems first appeared: *Christianity and Literature, Epoch, Fourth River, Gettysburg Review, MiPoesis*, and *Prairie Schooner*. Several poems were also included in *Energy Humanities: An Anthology*, edited by Imre Szeman and Dominic Boyer (Johns Hopkins University Press, 2017).

Shale Play

Poems by Julia Spicher Kasdorf
and Photographs by Steven Rubin

We thank the readers who made this book stronger: Brian Cohen, Alison Hawthorne Deming, Seamus McGraw, and especially Barbara Hurd, whose insightful foreword extends the implications of our work. Editor Kathryn Yahner managed with expertise and grace; designer Regina Starace performed a work of alchemy. And our families—Philip and Amelia, and Dana and Anjelica—generously spared a spouse or parent, sometimes on short notice, as we followed gas industry activities these past five years.

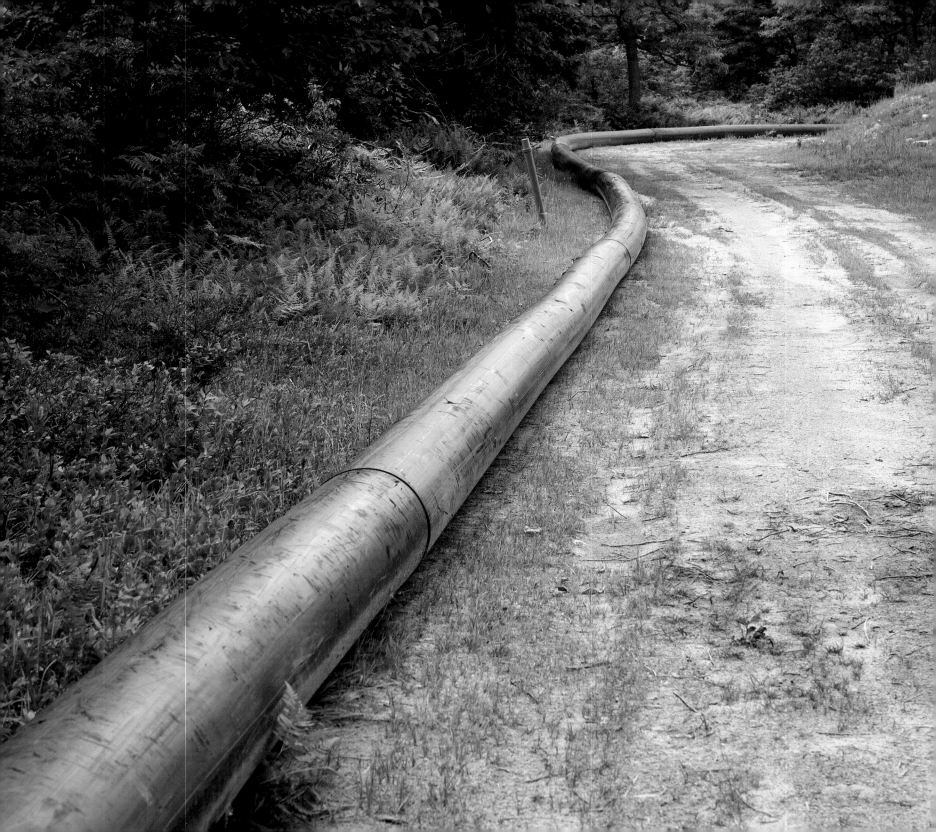

September Melon, Seismic Testing

Larger than my head, it rests heavy in one hand
as I lift it to my ear and knock for the thud

that says the center will be red and dense, wet
and sweet, studded with shiny black seeds,

a gift this late in the season. Where we live,
among boulders and trees, thumper trucks gain

uneven purchase, so a rig, driven by one man,
traces a grid through the woods, grabs trees

with a metal claw, holds them until a blade saws,
then tosses them aside. An auger drills shot holes

and sets the blast with radio-controlled detonators
thirty feet down. On Sunday morning, they blasted

when everyone else was at church, the professor says,
certain the men trespassed on his unleased land.

A seventy-year-old woman stands up in a public meeting
to tell how she showed the gas men a map of her farm,

said blast anywhere but here and here. They agreed.
But wouldn't you know it, they blew up the two

spots where she'd buried her husband and horse.
Another landowner begged for a day to move

his bee boxes. The gasmen refused. What happened?
I asked, imagining the furious hum and spray

from gilded hives when the earth shook.
The man shrugged, not the point of his story.

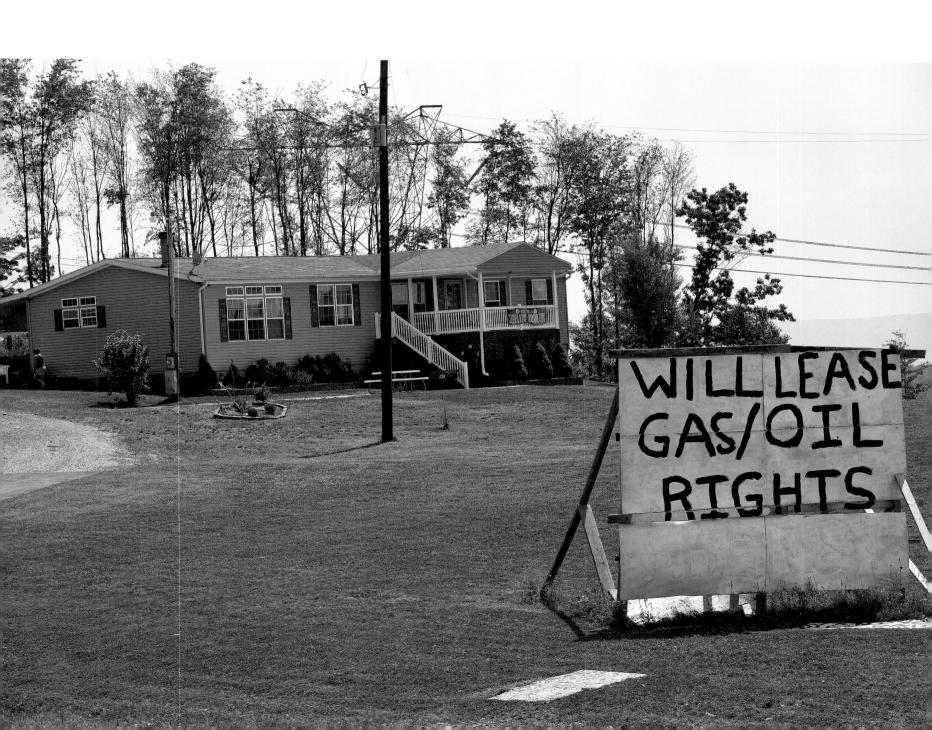

Fry Brothers Turkey Ranch with Urbanspoon and Yelp Reviews

Good Food at a Good Price. Who wouldn't pull off Route 15
at the crest of Steam Valley Mountain and take a table with a view
of helicopters dangling the pendants of seismic testing,
a gang of white pickups, or the bald strip shaved up the ridge
where the pipeline was laid?

*Good, good, good. I was working close by and we ordered 30 some burgers
with fries and they were delicious. The waitress, witch I forgot to get her name,
was very attractive and oh so friendly, I hope I didn't bother her too much but I
was kinda harassing her with my humor that I hope she found humorous.*

The young waitress says last winter they didn't have to lay
anyone off. The older waitress says the gas just helps out a bit:
on farms around here, you see a new tractor or truck,
someone's put up a garage or painted his house. Look,
over in Dimock, their water was bad before the gas came.

*Horrible, keep on driving and do not bother to stop! Had the turkey and waffles.
I was served a plate covered with the weirdest yellow colored gravy. Keep
driving and eat in one of the nearby cities.*

On knotty pine paneling, framed photos and typewritten signs:
the mountain named for a steam-powered lumber mill,
farmers set their watches by its whistle since 1849. Route 15
came through from Williamsport in '29, and overheated cars
stopped at a spring on the summit to water their radiators.

*Every year in October for my birthday, mom & I drove up to the Ranch. The trees
are lovely this time of year. We would go to the Pennsylvania Grand Canyon.
One year we even packed up turkey scrapple to bring home. It was great!
(Hubby liked it & he is picky about scrapple.) Mom passed in '06. Haven't been
back. Someday maybe with my daughter.*

William and Raymond Fry sold meat, butter, and goods baked
by sisters Mabel and Bessie at the Williamsport market.
They began raising turkeys in '38, opened Fry Brothers
Turkey Ranch and Dining Rooms on Mother's Day, 1939,
and expanded immediately, thanks to the $1.25 turkey dinners!

*Decent place to stop when you're in the middle of nowhere. The turkey is real
but the potatoes and stuffing were so so. For something different, order the
pickled eggs and beets.*

Across the highway, earthmovers crawl behind a steep bank
frosted in pastel-green grass seed. It's them gas people,
the waitress says, planting a brown plastic tumbler of water
by my plate. They're digging a retention pond for the water
they'll pump up from the Susquehanna. Want fries
or mashed potatoes with that hot turkey sandwich?

*The behavior of some diners detracted from our experience, but I don't
think they were regulars—the place can easily get loud, though. We were
disturbed by the taxidermy. The problem wasn't that it was there, but that it was
noticeably dusty. Our server seemed scared of us, perhaps because I pulled
out my netbook to look for some WiFi. Oh, and their turkey dinners get served
with a scoop of rainbow sherbet. Just so you're forewarned.*

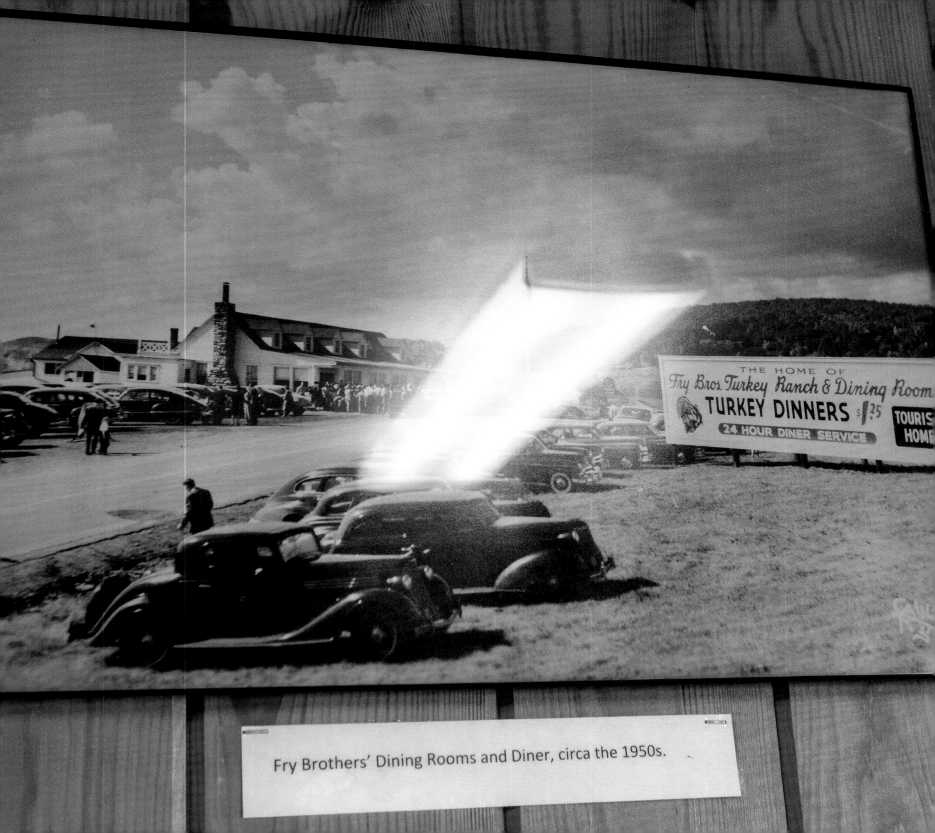

Fry Brothers' Dining Rooms and Diner, circa the 1950s.

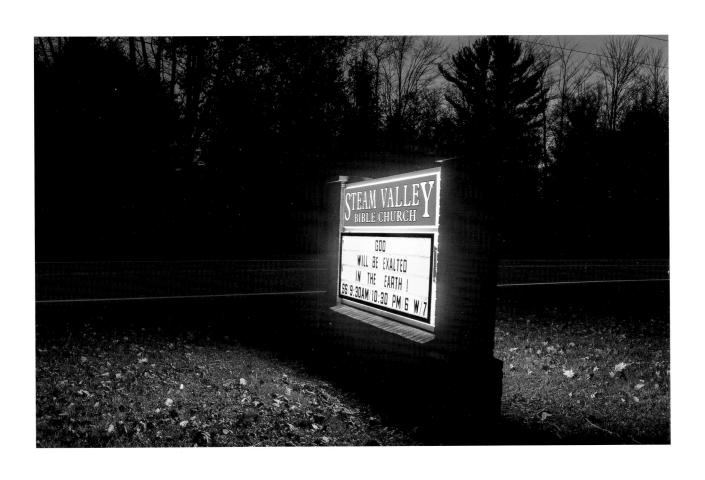

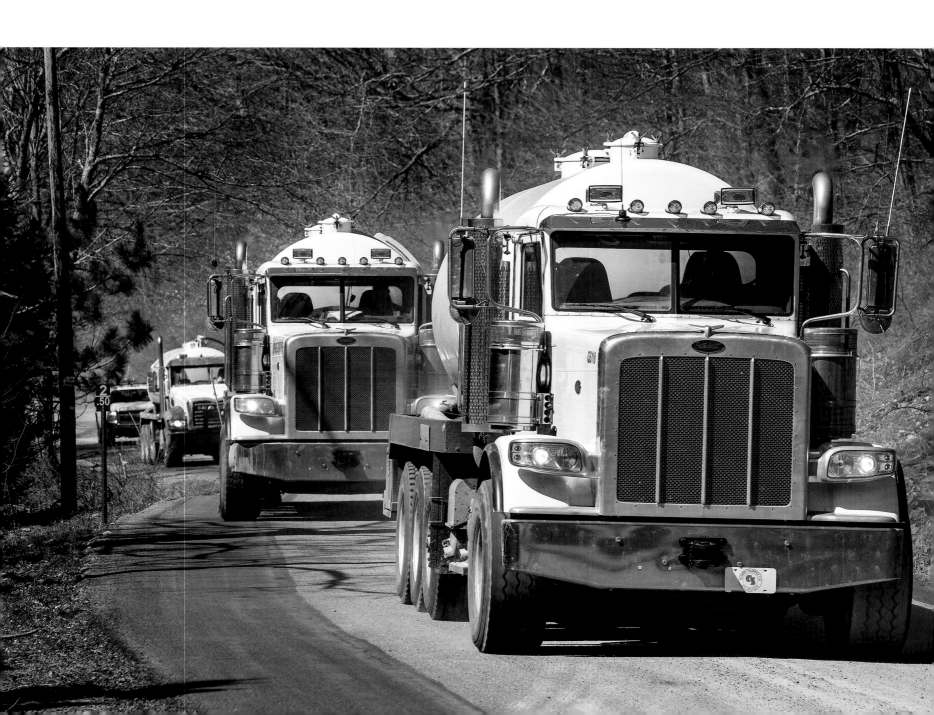

Happy Holds Forth at Fry Brothers Turkey Ranch on Route 15

A tall man with a mullet and jumpsuit strides
toward a booth by the window, orders
a hot turkey sandwich, water with lemon, and pulls out
The Shack, paperback my mom once urged me to read.

The shack is a house you make from your own pain,
according to the author, a former hotel night clerk.
The man prays over his plate, then looks up at me,
watching, and smiles. Where are you from? I ask

because that's all I ever think to say. West Virginia,
but I live in Fairchance, near Uniontown. I tell him
I went to Ohiopyle for my prom picnic, and that's
a lovely part of the state he's from. Naah, he says,

it's just a river and mountains where someone
built a hotel and store a long time ago to make
money. Then he waves at the taxidermy:
look at those turkeys—how many eight-dollar

sandwiches come off one of those birds? It's just
people taking what they can, like we're fracking
some poor farmer's field out on Route 6 right now.
Calfrac—like it says on the suit—Calgary's the base,

fracking's what we do: we pry the earth apart
with chemicals, sand, water, and enough pressure
to strip the paint off your car. It's government and Big Oil
in cahoots, like usual. I have a load of hydrochloric acid

in the parking lot. He lifts his fork. I ask how long
he's worked this job. Five days. It's six on, three off,
six nights on, three off. George Bush—and I voted for him—
changed the law: used to be seventy hours a week in a truck

meant seventy hours, but now if you're standing or driving
on a service road, it doesn't count. While I wait for my stage
at the well, it doesn't count. Can't sleep in the cab,
can't escape the noise and odors. I'm not a bad person.

Sure, I have regrets: wish I hadn't been an athlete,
should have listened to my teachers, shouldn't have
let my sister and girlfriends do my homework.
But I'm not a bad person. I was an ironworker,

had a job in Morgantown supposed to last two years;
it lasted five weeks, so I told my wife I'll drive truck:
warm in the winter, cool in the heat. She's a lawyer
but doesn't make that much. Public defender, she says

everyone deserves a fair trial. But look: what we're doing
out here is not good. I sit forever in the cab and pray,
Take me now! Are you a Christian? I'm sorry,
 it's just that I'm so tired. The poison that comes up,

they pump back into wells. It might seem OK now,
but what's to say it will stay put for two years
or ten, or how about when our grandchildren grow up?
You ever read *The Shack*? It's my life, the first five chapters.

I read them over and over. My nickname's Happy.
Happy, I tell him, your lunch must be cold by now.
See what I've done?

F-Word

The industry spelling of *fracking* is actually *fracing*.

Without the *k*, it looks less violent:
water pressure creates fractures that allow

oil and gas to escape—as if they
were trapped—*under tight regulatory control*.

Blame the fracktivists, frackademics. A bumper
sticker claims, *I'm surrounded by gasholes*.

Frack her 'til she blows, says the T-shirt stretched
over a roughneck's belly at the Williamsport Wegmans.

Frackville, PA, named for Daniel Frack, *vrack*
from Middle Low German: greedy, stingy, damaged,

useless. *Are you going to say what the word suggests,
a student timidly asks, . . . to women, I mean?*

Fracket, a sophomore explains, is that hoodie
worn over a spaghetti-strap dress to a frat house,

an old jacket that won't matter if it gets stolen
or left behind on a flagstone patio, splattered

with someone's else's vomit.

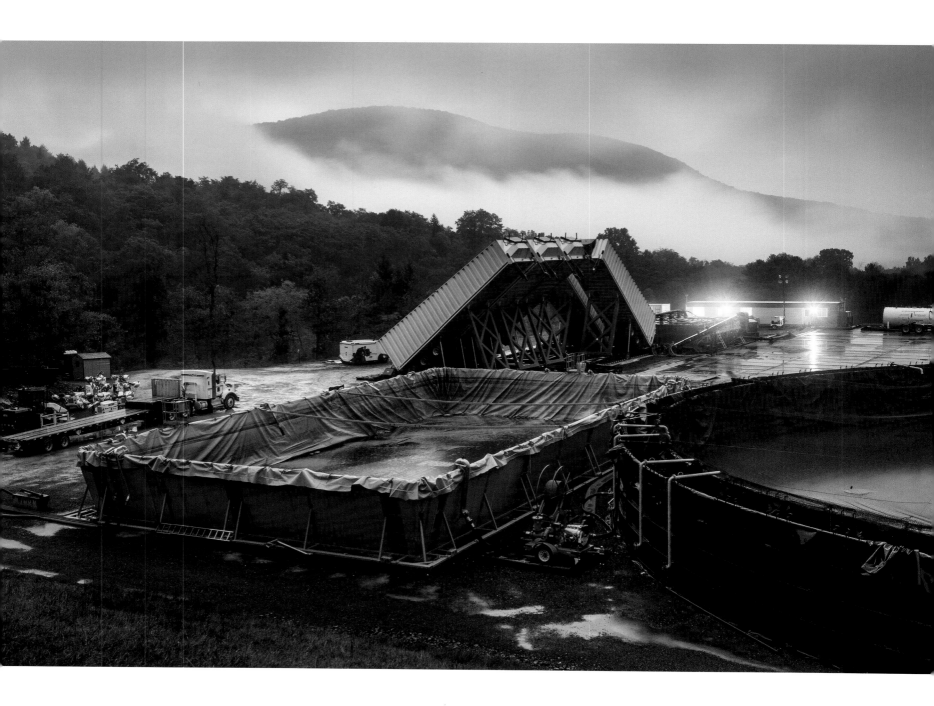

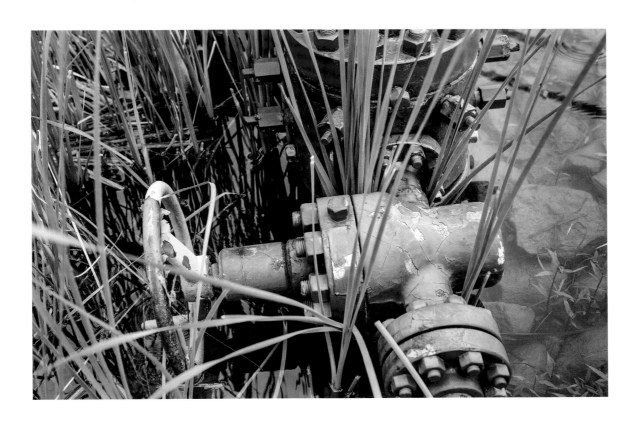

A Mother Near the West Virginia Line Considers the Public Health

The industry thinks I'm too dumb to back down; they don't know
I do this for my mom and dad. They were sixty-nine and seventy-one.

He had pulmonary fibrosis, worked with asbestos all his life. She grew up
near the coke ovens back when kids were sent into the mines to pick coal.

So they both had lung problems, but their home, the next holla over,
sits 350 feet from a compressor station. We sealed the house,

set up an air scrubber, but four of their neighbors passed last year, too.

————

We bought the coal rights to our 115 acres because we know
the company will come up to your front door, but we let the gas rights go,

just didn't see this coming. A gentleman from New Jersey leased our land.
One day we come home to find pink ribbons tied in the field. Then bulldozers.

They put in four shallow wells and a Marcellus well on a five-acre pad seven
 hundred feet
from our porch. The workers come in by the busload. All those strangers

on our land, 24-7, could have been rapists or pedophiles. For about a year
they didn't have a Port-a-John. I looked out my window one morning

to a guy peeing in the driveway. The dog brought in used toilet paper.
The workers have to be young, strong. Kids in trucks twelve to sixteen hours
 a day,

that should be placarded *hazardous waste*. They live on junk food;
I know because we picked up the wrappers. Then our dog disappeared.

We saw Sara's tracks in the snow go right up to the well pad.

————

When crayfish died in our spring, we knew the methane had migrated.
Now you can light it on fire. Our neighbor put in a waterline; we guessed

their well had gone bad and they'd settled, but they paid for it themselves.
We had water buffalos two years before we paid to run a line in from the road.

When they laid the gas pipeline, those big trucks drove over our waterline
and busted it up. When I hollered at the drivers, I got dragged into court;

me and our son, four years old then, both got an injunction.
They tried to say I'm an unfit mother, too, but the judge wouldn't hear it.

I look at pictures of my little one from that time, and he has the same dark circles
under his eyes as the Hallowich kids. He'd get terrible stomach pains, nothing

we could do but hold him. My older boy had the nosebleeds and rashes.
I couldn't keep him inside all the time. I'll show you pictures. If you speak up,

you get more security. We had guards here 24-7, armed and unlicensed
in Pennsylvania. They got real interested in my walks down by the crick.

One asked me, What do you do down there in the evening? I said, I walk
and I have pawpaw trees, want to come along? He could have used

the exercise, so he walked with us, and I got to know the night guard.
His mom was sick the same time mine was. We're still in touch on Facebook.

———————

They drilled the gas pipeline on a weekend, didn't go where the DEP said,
so it blew out in our crick—bentonite and Residual Waste clouding

clean water stocked with trout. That's when I cried. That crick flows
into the Mon, and people get their drinking water out of that river.

Another side effect of the drilling no one thinks about is all the swearing.
And it's not just the men.

———————

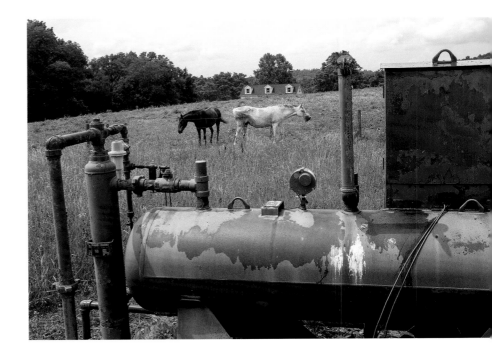

Alternate waste disposal on site means they can bury radioactive
drill cuttings in your land. When they drained the frack pits,

they shook the tarp and bulldozed the sludge into the ground, too.
There's places we mow now, but we don't feed that hay to our horses.

I can't dig or plant a post there. Why don't they tell us
not to grow food or let beef graze back there?

The stock sale registers animals now, so if I sell hay to a neighbor,
he sells his steer, and someone's sick from the meat, that comes back on me.

————————

People collect royalties on this well a mile away. We just care for the place
and pay taxes. The well tenders come about once a week

to the shallow wells and every day to the Marcellus. Two or three
times a week water trucks come in here and draw brine, and every two weeks

they blow it down, so whatever's on the line goes into the air.
Once the brine tank vented for forty-five minutes. My horse's eyes swelled shut,

and one eye went blind. They've had the nosebleeds. There's a big gum tree
near the well that loses its leaves in the middle of summer.

————————

We saw clouds of silica sand blow off train cars over the little league field,
and someone was holding a newborn there with us in the stands.

When I complained about them parking silica trains by the elementary school,
the gentleman said, It's just sand; your kids play in it.

————————

We didn't have internet before this, but you have to follow the permits
because the industry tells you nothing. You have to go to the courthouse

and pull your file, and when you find out what they did to your land,
you're just sick. Let them think I'm too dumb to back down. My son

won't play on any T-ball team with industry logos on their shirts.

Boarding Group 5, Flight 1219, Denver to Spokane

Everyone complains about the weather, the wait.
The guy ahead of me, tanned face and huge snow boots,

says he started out in minus fourteen, North Dakota.
Sure he works the oil fields, nothing else out there

but bars. He goes onto the rig right after they frack.
Yes, he likes the work, done it four years, but misses

his wife and kids. It's fourteen days on, seven off, and a plane
stuck in Denver can cost you a day or two.

The wife has her hands full while he's gone, but
she's even busier when the fourth kid comes home!

Sometimes he drives; it's supposed to take twelve hours,
but he does it in eight. Last time, he pulled in just as she

was leaving for work, and she idled in the driveway
long enough to say, *You didn't sleep like you promised.*

You drove over a hundred again. Yeah, they burn off
the gas you all frack for in Pennsylvania because

all the pipelines are out east. Last week his rig
flared off ten million cubic feet, felt like working

under a jet engine for a few days. Yes, he's heard
of that well fire in Greene County, works with a guy

who once worked with the kid who died. It's dangerous,
but nothing's worth a human life. Once, in 104 degrees,

after six hours on the floor, he stopped to drink
a bottle of water. Supervisor yelled at him for that.

He told that man, *I need a drink. I need to sit down.*
Maybe I'll drink two bottles. Now he works for a firm

that's more laid back. They want you to end the day
with the fingers and toes you came in with. Then

there's bitter landowners. You can tell which ones
sold their rights for shallow wells back in the '80s.

He drove onto a farm, and the owner stood in the road
with an M16. He told the farmer he wasn't there to make

trouble. Just doing his job. Guys say he should get work
in Pennsylvania, but that's so far from home. Then he grins,

and I see a gap in the side of his teeth. *And you?*
Business or pleasure? I could say both, but instead

I mention a small college in Spokane. He never heard of it.
We take seats on the plane without exchanging our names.

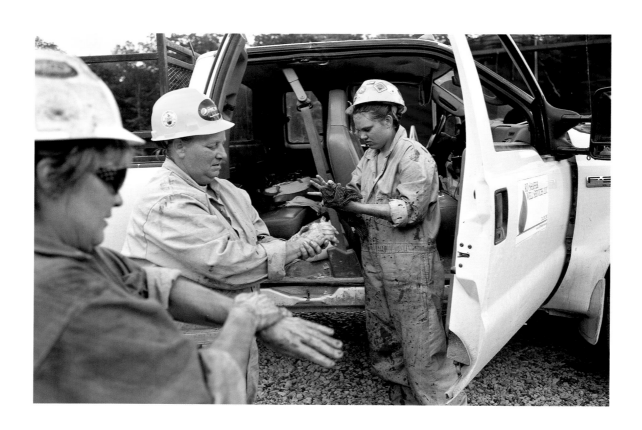

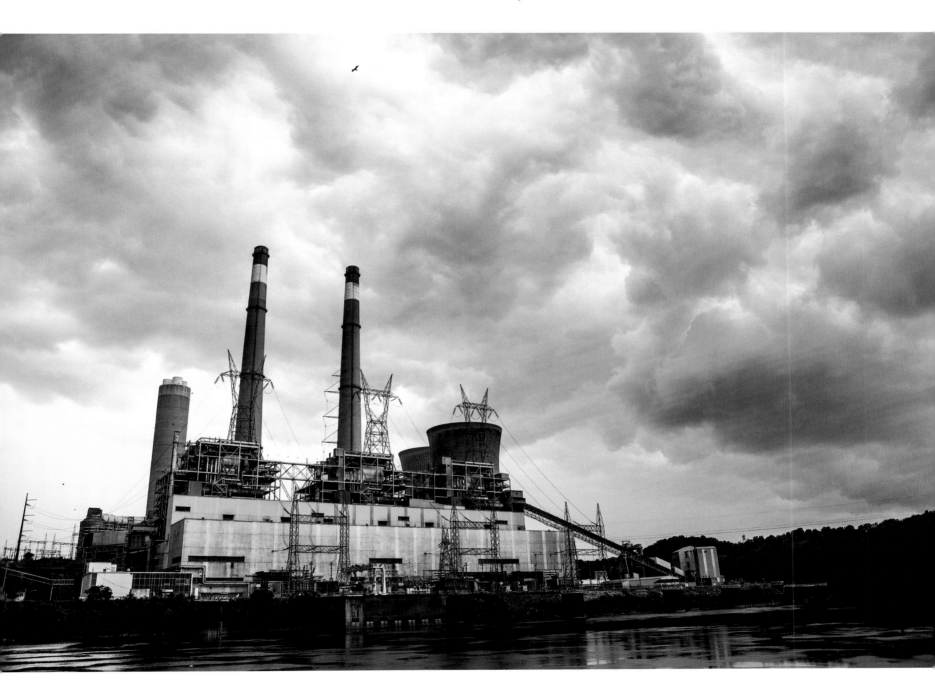

A Pastor and Part-Time Security Guard Wonders About the Work Ethic

Every minister in Masontown is half-time, even
the priest. My congregation's mostly older folks
on fixed incomes. There's one coal miner still working,
some on disability, a couple nurses, an electrical engineer
at the power plant near Morgantown, one man retired
from the mines. When they shut down the coal-fired
power plant at Hatfield's Ferry, October of last year,
that took a lot out of this community: barge traffic off the river,
truck traffic off the roads, more than a hundred men laid off.
Environmentalists did that. They say coal pollutes,
even though the company constantly tries to improve
the stacks. Nothing's good enough for them.

Listen: gas is good for this place. On the Honsaker farm
by the church, twin boys—Bob and Ronny, Bob just died—
had a dairy, but they couldn't keep it going. People just don't
want that kind of work. So now there's ten Marcellus wells
on that farm. A lady at church left some land to the twins,
and there's a Marcellus well working on that farm, too.
My son tended wells for Atlas then moved up. I ran into a guy
at a wedding last Saturday who tends wells, and he loves it:
drives around in a company pickup, gets outside,
makes good money an' 'at. My barber's grandson worked
as a mechanic refitting army tanks at BAI on Route 119,
but that plant closed, so he tends wells now, too.
Since the mines shut down and the mills closed,

people here have to travel for work. My neighbor gets up
at four to be on a gas job by seven in Butler. When kids
graduate from high school, they have to leave. Maybe
that can change now with natural gas. Of course,
there's the ones who don't know how to work. I heard
of contractors who pick guys up at their homes
on the way to a job so the lazy bums won't leave the site
at lunchtime! And there's drugs. We're raising my daughter's kids
because their dad's lost. You see these guys up at the mall
standing around, holding up their pants. Come on now!
How you gonna get a job like that? Oh, I've got plenty
to keep me on my knees.

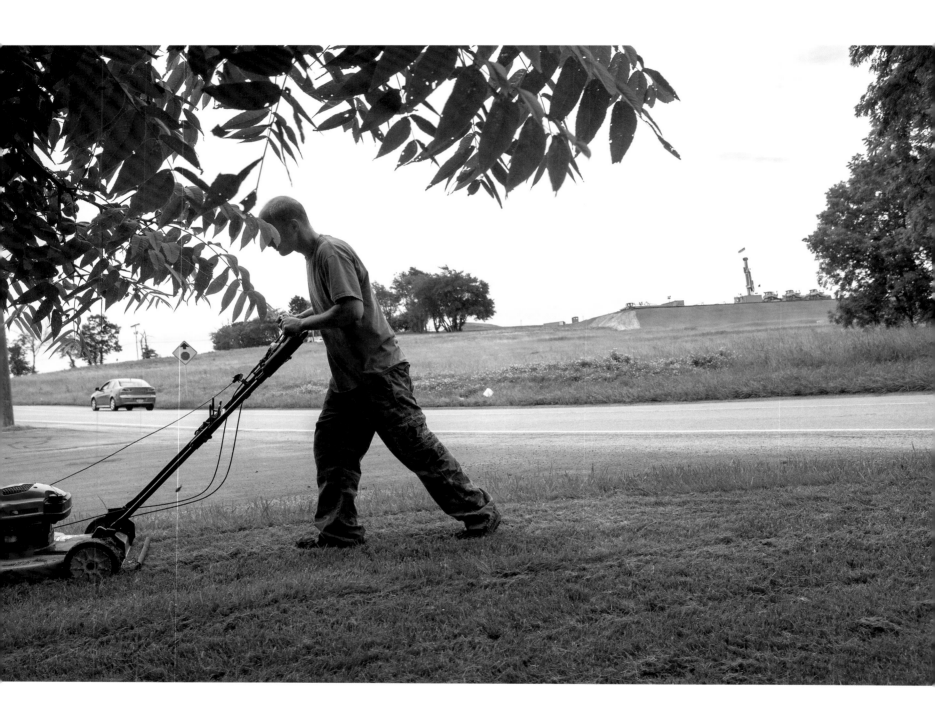

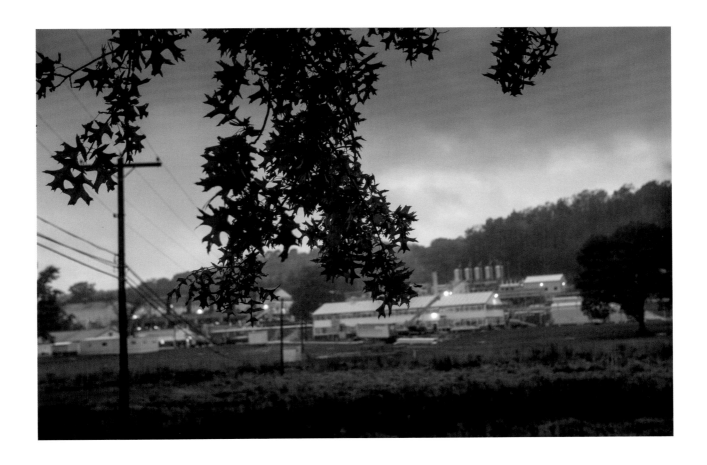

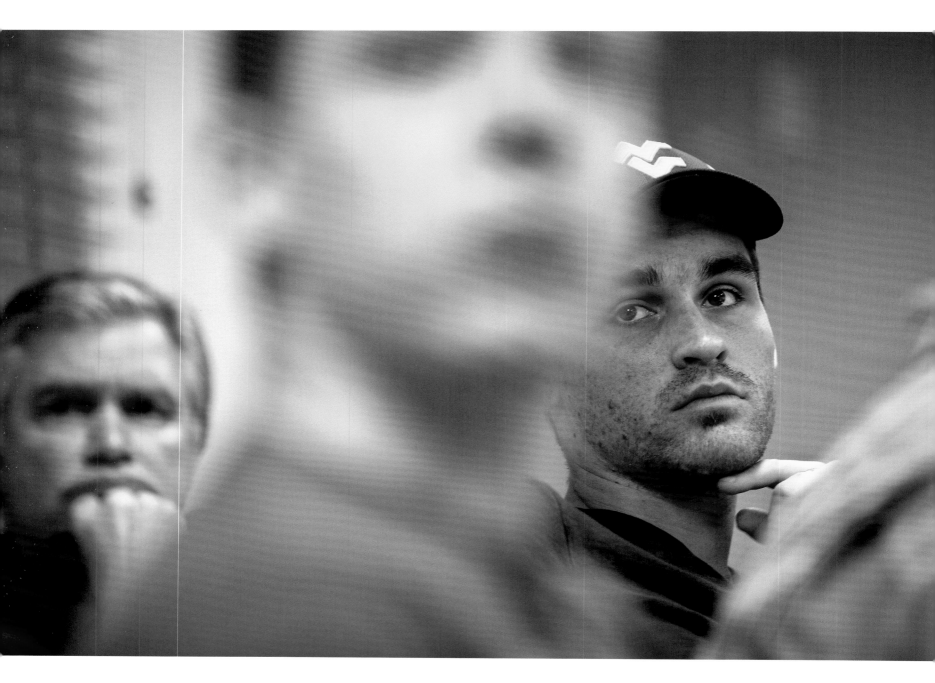

Gathering Lines

On 22, old road named for William Penn, drive west
past Streekers, Cheaters—*live dancers!*—the Beehive.
Pass paper signs staked in the ditch: *Stop the War
on Coal, Fire Obama* and *Cash for Your Used Guns*.

On one billboard, a blonde aims a pistol: *Yes, you CAN
learn to shoot*. On another: *Washington spies
on your phone calls and e-mails. Call your congressman*.
Dismantled rigs on flatbeds creep toward the Alleghenies.

At Delmont—*one of the largest natural gas storage sites
in the nation*, brags Westmoreland's website—turn
south on the tollway. On 119, pass new Baker Hughes offices
behind mirrored windows across from the old VW plant

where our dairy princess's dad got his first factory job,
then quit. Farmers would rather milk cows and drive bus,
broke, than punch a clock, stand inside on a line all day
and answer to a boss. When the factory closed in '88,

one laid-off man shot himself in a car outside the plant
on the straightaway kids used to drag race. At a dozen,
the union rep from Mount Pleasant quit counting
unemployed suicides. No one loved the Rabbit anyway.

The auto plant now houses Westmoreland County
Community College's ShaleNET, courses for credit
or seventeen-day trainings for entry-level oil and gas jobs:
First Aid, Rough Terrain Forklift, Aerial Work Platform,

Defensive Driving. Local radio still plays anthems
from driving around in the old days: "Dirty Deeds, Done
Dirt Cheap," "Flirtin' with Disaster," "Highway to Hell"; sweet
grass and timothy hay blast through the window.

At 981, Morewood—beehive coke ovens and the coal patch
razed to make a highway and strip mines—nine strikers shot
in April 1891, then buried with the remains of 109 hunkies
blasted from Mammoth No. 1 that January when

*a miner's oil lamp ignited the cruel gas . . . the afterdamp that
followed the fire-damp explosion suffocated nearly every workman
. . . the mine is now on fire; it is feared the bodies will be cremated . . .
wives and families left wholly dependent on the charity of the world . . .*

*work has been exceedingly scarce since the dullness in the demand
for coke*. Soft coal baked to its silver bones; so close to pure carbon,
it's uncrystalized diamond. At the Coal and Coke Heritage Center,
the archivist says the most common request is record

of a relative's death in a mine. Across Route 119, pneumatic bulk
tankers for silica sand shine in the sun, such stainless steel.
When Walmart's glass doors parted, the tax collector from Dunbar
stepped into an odor so foul, people ran to their cars.

Coat over her head, throat and chest burning, she called
National Response. Deep breaths still hurt. Five died lately
from brain cancer in Dunbar, but when she brings that up,
people say, *Wha da hell, Marigrace, we all die sometime.*

Wha da hell, you might get hit by a truck tonight! They joke
the gas companies don't hire locals because no one around here
can pass the drug test. Cowboy Boots says, This place is crazy;
y'all have deep mines that catch fire, an' does anyone know

where they are? After the public hearing in Uniontown,
men paid to sit in back claimed the noxious smells that gag
our homeplace come from meth labs in the hollow. *DEP?
Don't Expect Protection. Hit a deer? Bring your car here.*

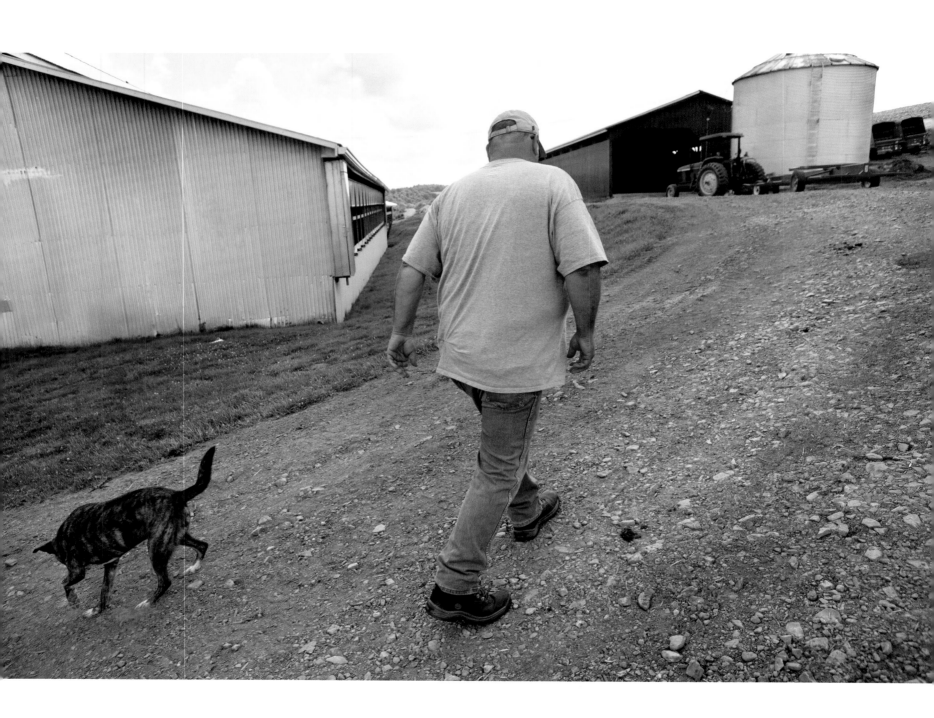

Citizens Have Their Say Before the Fayette County Commissioners Uphold the Lease of German-Masontown Park

Chevron is in this area to stay. We have a lot of land leased around the park, and we intend to develop this. —Industry representative in the audience, August 18, 2015

Let me remind you that we had the Lanko 7 well explode
due to preventable human error and kill a man, then
 Chevron
sent around pizzas. We've had a number of close calls.
Near the Kitko well, we still have a deep mine fire burning.

Chevron is here. I have a question for you, mister:
How much did Chevron contribute to Mr. Ambrosini's
 campaign?
Did you funnel money through his family?
Did you buy any one of them lunch one day?
You know what, Vince, I'd a thought better of you.
It's a shame you people don't care anything
about the people in this county.

My only real concern is that we hold Fourth of July picnics
in that park. Gas and fireworks don't mix.

I want to ask you one question:
Have you done a health impact study?
I trusted the DEP, and you know where that got me.
There's a lot of sick people out where I live.
I didn't expect my neighbors to die around me.
Yun's commissioners aren't doing your job!
Yun's are going to be held responsible.

Chevron will make a charitable contribution
to Dunlap Creek Park to build new restrooms.

This lease will help us finish the Sheepskin Trail
and build handicapped restrooms. People come
from all over to ride the Great Allegheny Passage
and Sheepskin Trail to Dunlap, including Hawaii and Alaska.
They appreciate the people of Fayette County.
Someone even made a donation to one of our libraries
after coming through on the trail.

When you met with Chevron to negotiate this contract,
how many commissioners were in the room?

Shame on you! The only worthwhile commissioner
up there is wearing a skirt! Zapotosky is my nephew,
and I can tell you he always was a liar!
I've been dealing with oil and gas since 2002.
I own sixty-five acres next to a pumping station
that was built five years before it was permitted.
If I built a garage without a permit,
you'd be in my backyard in no time.

Was there a public meeting to discuss this contract?
No, this contract was negotiated behind closed doors.

All strata means these folks can drill
to the center of the earth for $188,000;
that's about a buck-forty per person in this county,
and postproduction costs will be extracted
from the royalties.

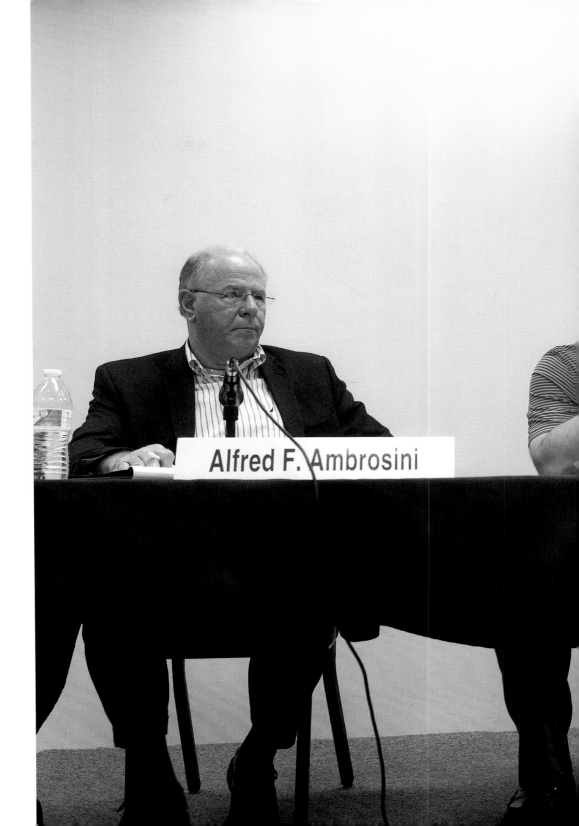

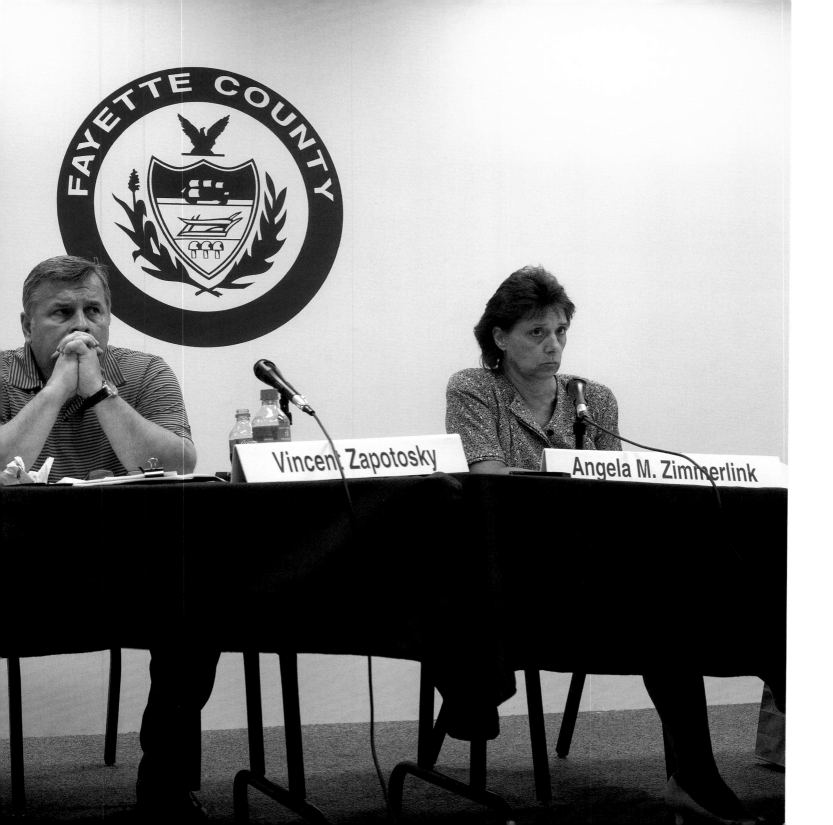

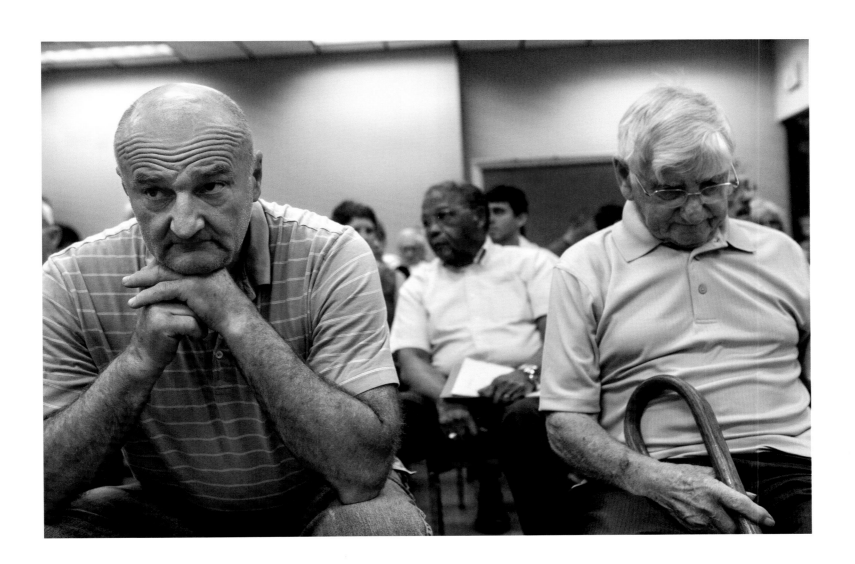

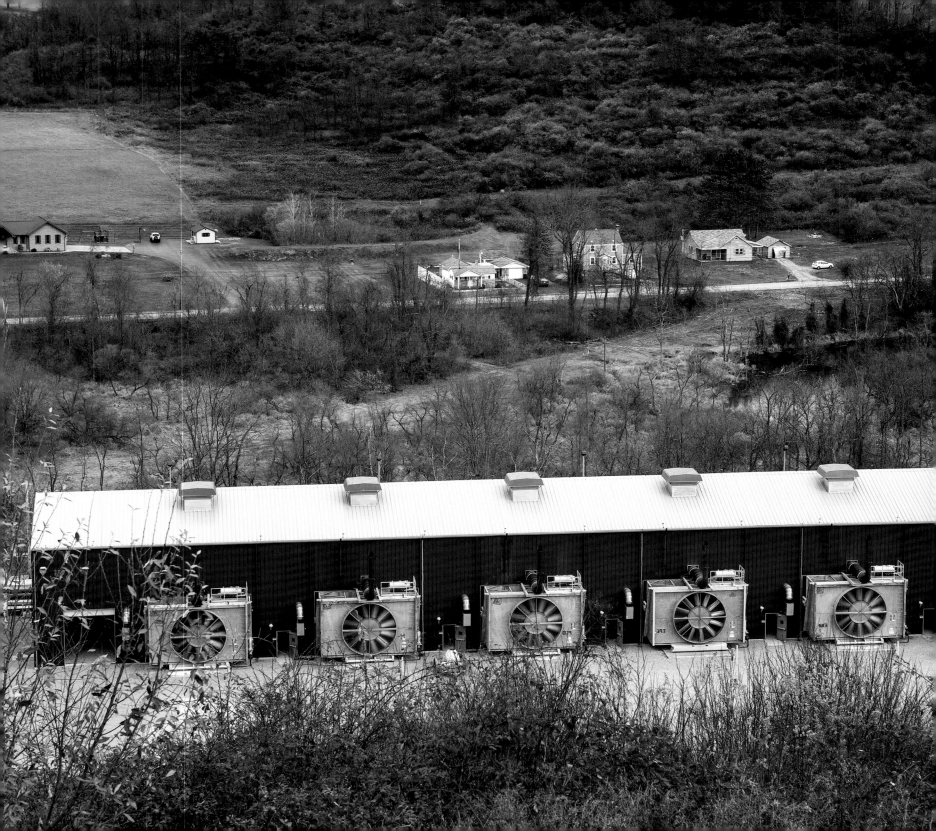

On a Porch Across from the Shamrock Compressor Station, a Tiny Lady Tethered to an Oxygen Tank Chats with a Stranger

This hose is tied to a big machine in the living room,
but it's long enough to reach to the cellar freezer,
and I can water these flowers if my friend fills the bucket.

I applied for a portable tank. Medicare takes forever,
but they saved my life. I went into the hospital spitting
up blood, and they figured I needed a heart operation.
They never did find out why I spat blood.

The Blessed Mother in the corner there used to be blue.
I brought her with me when I moved up from the farm.
I was eighteen or nineteen, and this place looked like a shack.

I met my husband at the Cardale Polish Club.
Back then, you didn't go on dates. They'd have a band,
and you danced with the men, then you got married.

My brothers teased me: you're moving to Shamrock,
you're going to the coke ovens. But I said no,
I am moving to New Salem Road!

My husband worked in the steel mill in Duquesne.
Men rode a bus from Uniontown. On the way home,
the driver stopped once or twice so they could buy beer,

then at Uniontown, they all went to the bar. He never
came home straight. I never knew him straight,
but I took care of him when he got sick. When he was dying,

I called the priest for last rites, even though
he didn't like going to church. He passed in 2008.

We had a yard sale, and this man from Uniontown
came to buy my husband's car. He couldn't afford it,
but he talked to my sister and me and gave us rosaries.

That's my friend. He does for me: puts out my pills,
buys groceries, mows the lawn. I always pay him.
I put him on the deed of the house, but you won't see

no man staying overnight here, honey. Do I need
a man bossing me around my own place?

The first year after they built the gas plant, they sent me
an arrangement at Christmas. A florist brought it
to my door. They sent a fruit basket up to the neighbors,

for their kids. They had a meeting with a nice dinner
and invited all of us. I didn't talk at it.

Last month, my neighbor lady passed away. Three days
she laid up there in her bed before anyone came.
She was only seventy, ten years younger than me.

Sometimes I hear a banging noise all night long coming
from that Shamrock plant, or a siren. When the leaves are
 down,
I watch them from my bedroom window with my scopes:

the man who climbs the ladder and the man who checks
something on a tank, they don't even know I'm looking.

The other Blessed Mother I bought at Walmart, only $30!

Orient Patch, I was born. My dad worked in the Orient Mine,
but he died when I was little, so our mother bought forty acres
on Snuff Ridge and raised all seven of us on that farm.

After eighth grade, I washed dishes at the Paradise
 Restaurant
in Uniontown. My sister was head waitress.

My husband and I fixed up this place. We had parties
right here on the patio. Oh, you should have seen
my mother dance on this driveway!

Two of my brothers were in the service.
The brother who moved away worked for Fisher Body;
he only missed one day of work in thirty years.

My grandparents come from Old Country.
That's all they said. You know, the other world.
I can sing a little Slovak, but you have to stomp your foot.

I made five hundred nut rolls for my great-nephew's wedding.
I used to bake for the feasts, too. I make, I give.

I should have this carpet replaced. My friend
duct taped a tear there on the step, but it should be
 replaced.
I just haven't felt like doing it. I don't know why.

I can't go to church with the oxygen, but I mail
those little envelopes, five dollars each time, and after a
 while
that adds up. The priest brings communion here at my
 house.

I sit with my back to the traffic, so people don't think
I just watch the road all day.

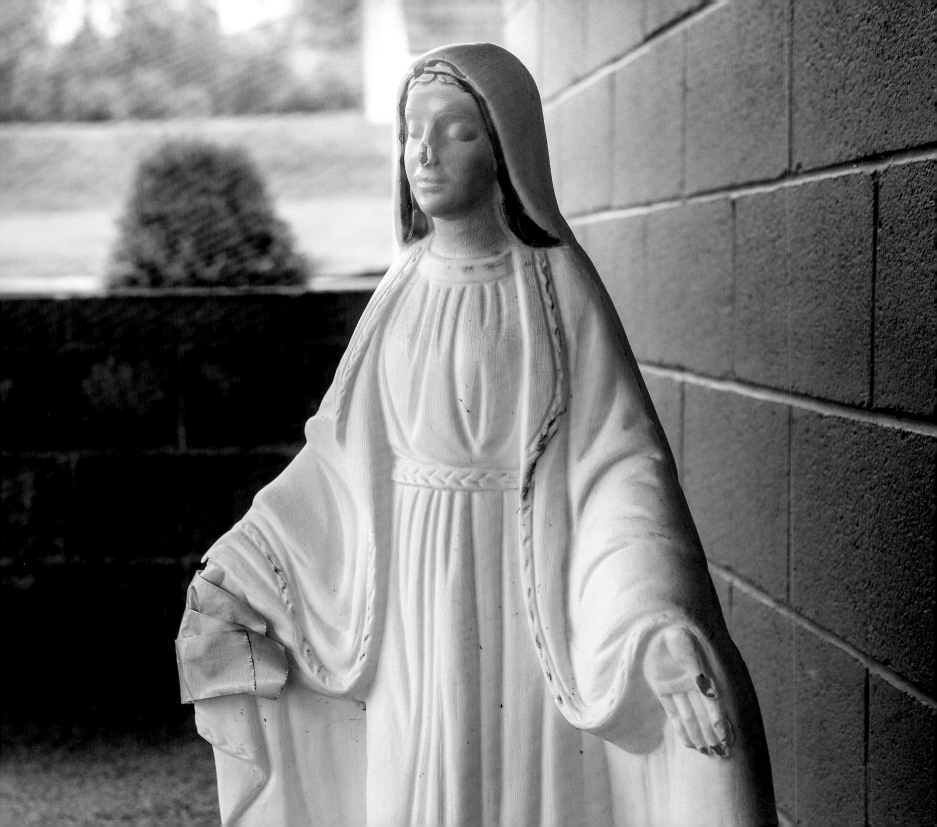

Letter from Mrs. Lois Bainbridge to Governor Duff

October 31, 1948

I am writing for "Smoke Control" in Washington County.
Pittsburgh has it, why can't Donora after the tragedy?

The Zinc Works has ruined Donora and Webster.

Perhaps this will awaken some of the high officials
who have built beautiful homes outside of Donora
in the surrounding country where vegetation will grow.

The towns of Monessen, Charleroi, and Monongahela had fog,
but there weren't twenty deaths as Donora and Webster had.

There is something in the Zinc Works causing these deaths.

It eats the paint off your houses.
Even fish can't live in the Monongahela River.

I would not want men to lose their jobs,
but your life is more precious than your job.

They closed the smelting plant today. You could breathe
normally without having the air polluted with acid fumes.

A beautiful town is now almost a "ghost town."

I know you are quite a busy person, but will you
please consider this letter just a little bit?

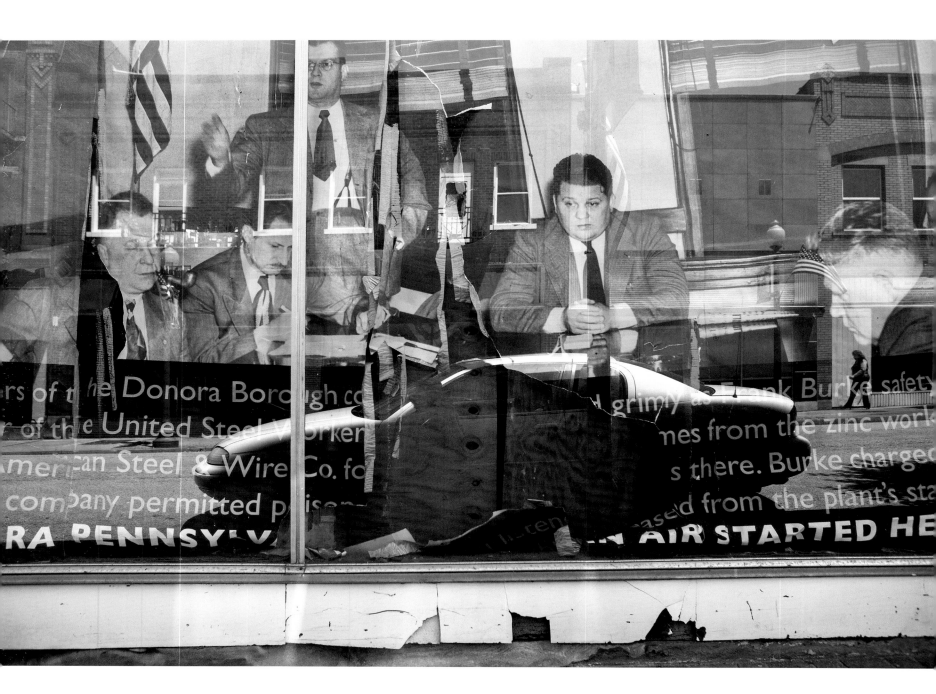

St. Nicholas of Donora, PA

For Eliot Kahlil Wilson

Eliot, here's how it is now in the town where your Syrian mom
squinted her way home from school that dim Friday afternoon,

bandana tied over her face, sulfur fog masking the sun.
Before rain fell, twenty lay dead and half the town sick,

nasty trick of the Zinc Works! But U.S. Steel blamed nature,
blamed acts of God. Nothing green grew within a half mile

of the smelting plant. Gullies rutted a grassless cemetery, exposed
coffins. *God don't like ugly*. Now, trees wreathe the river's bend;

sky's clear over silent streets on a workday. *Better than beauty
is a camel*, the Syrians say. In Horseshoe Bottom—renamed

for Andrew Mellon's bride, Nora, eventually unfaithful—
the Zinc Works closed in '57. American Steel and Wire spun

cables for the Golden Gate and Verrazano, then closed in '62.
The Donora-Webster Bridge demolished, that road as closed

as U.S. Steel's smog files or the Public Health Service's records,
as closed as most of the stores along McKean. Even the Smog Museum

was dark the day I stopped by: *Clean air started here*. Fine Design
Taxidermy was open, Anthony's Italiano, a Holiness storefront,

but shutters on Saint Dominic's, built by Slovak Catholics. Beneath
the blue-green onion dome at Saint Nicholas's, a bleached

Disaster Shelter sign still hangs from the brick. A brass knob
turned in my hand, and a trim woman with apricot hair

and cheekbones like Andy Warhol's came to the door.
What could I say I wanted—Beauty? Shelter? To see inside

her church? She abandoned trays arranged on long tables
for the poppy seed and nut roll sale and led me upstairs.

That icon means Mary the Mother of God keeps us safe, she said;
see her veil of protection draping toward the congregation?

Three years after the smog inversion, men worked full shifts in the mill,
then built this church atop a 1918 chapel erected by immigrants

from the Carpathian Mountains. *Work and prayer*, Benedict said,
but the Syrians say *Work is prayer*. Both plants are closed, jobs

flown south, Donora diminished by two-thirds. That window
shows Nicholas of Myra, patron of children; Mother Russia;

the unjustly accused; and itinerant scholars. It's true, Eliot,
look it up: an innkeeper minced and pickled three French students,

but Nicholas reconstituted them. Manuscripts show three nudes
shooting from a barrel, their heads the gold balls of the pawn shop,

coins the saint dropped down a chimney for a dowry to rescue
three girls from prostitution. This church—crystal chandelier

and gold mosaics above the doors—opened without a mortgage.
I said I was born on Nicholas's feast day, and she embraced me, kissed

my cheek, *I knew I came in today for a reason!* Pauline Petro—
200 pounds of flour, 150 pounds of walnuts ready to grind—

must be old enough to remember the smog, but I didn't ask. Instead,
she said the gas wells haven't brought any jobs yet. Some men begged

the priest to test for it under the church, but he said no.
If anything happened to this sanctuary, who would work on it now?

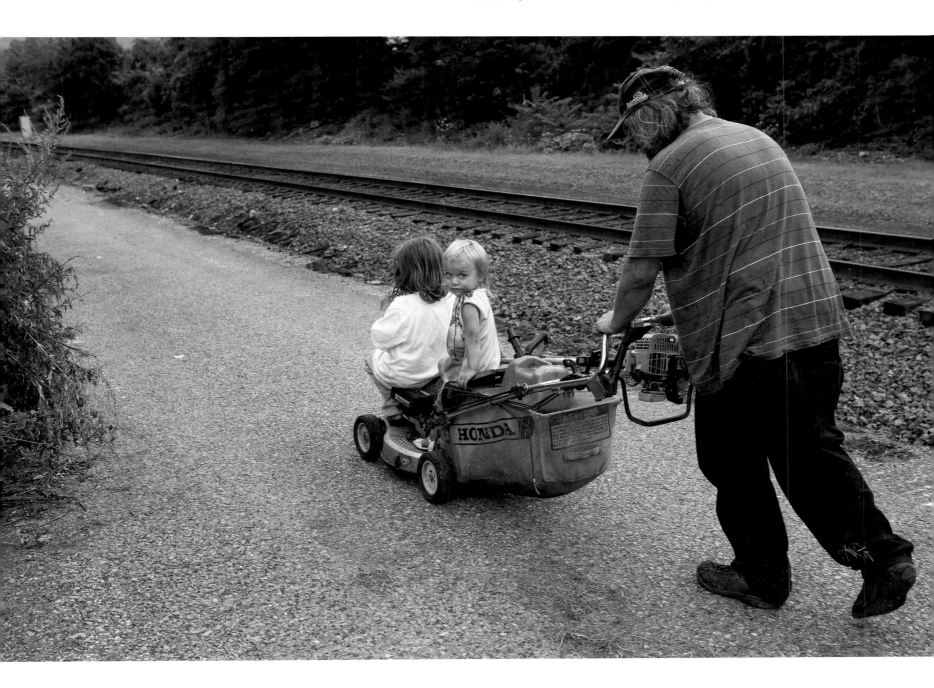

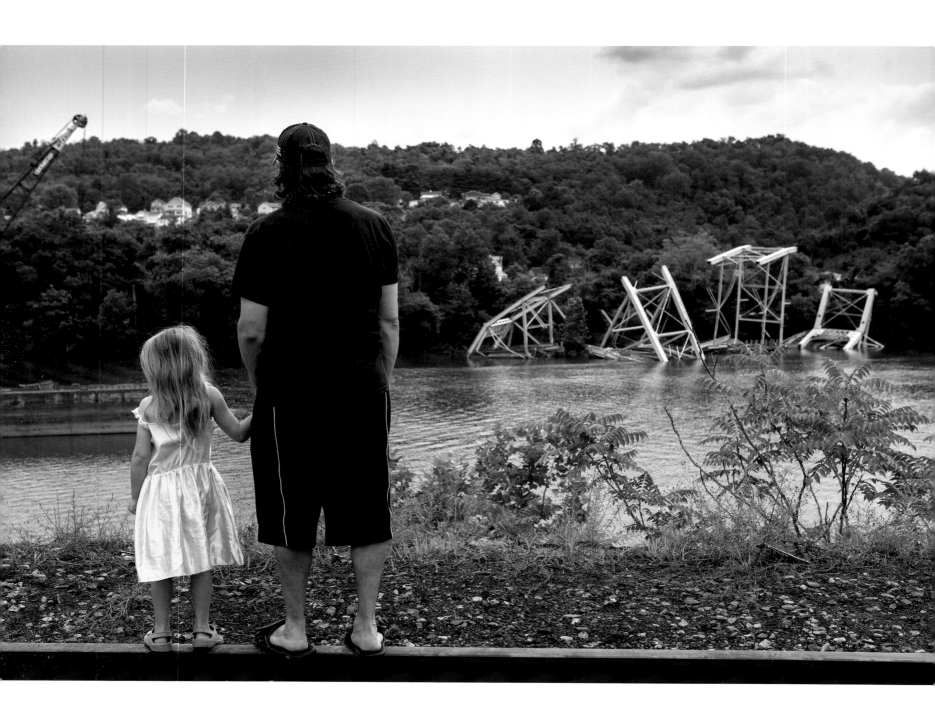

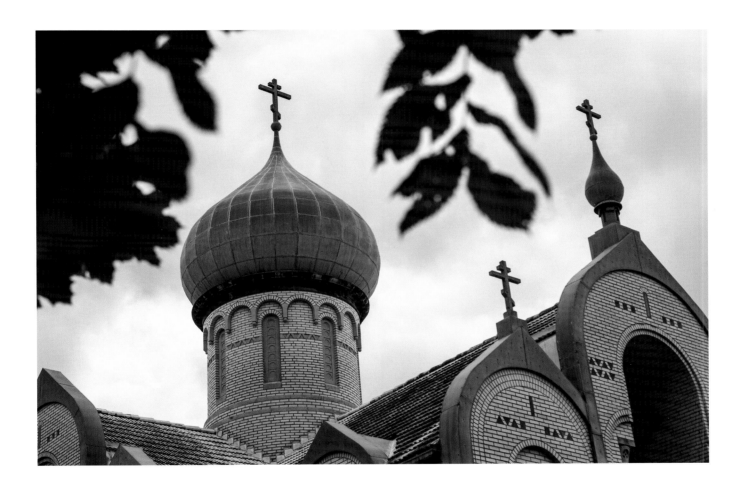

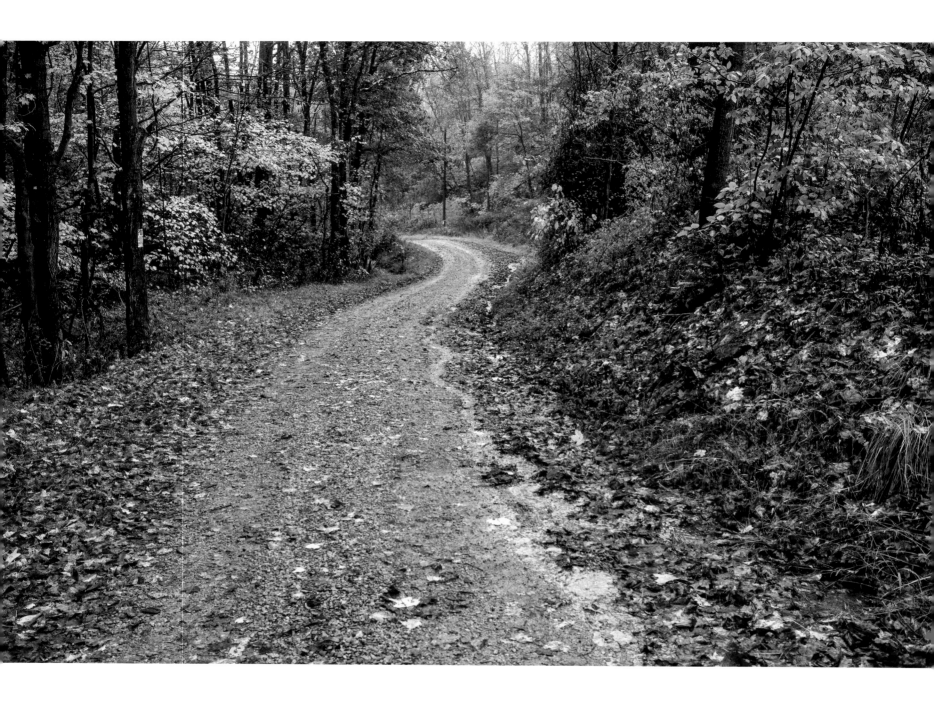

Along Hope Hollow Road, a Grandma Talks on the Phone

Best you don't come down here.
Last week we had a noise that upset a girl so; she drove
over and took pictures of the compressor station,
and a man showed up at her home demanding the phone.

————————

There's a funny-looking fog we get here,
a dangerous fog, no way for the wind to lift it.
A retired EPA man said we could have a Donora here
one of these nights, that fog could take all our lives.

The time I saw it roll over my home, it upset me so;
I had to start counseling. I can't go into the yard—
I get such a paranoid effect—not even to get into the car.

My daughter walked through a cloud of chlorine smell
that put blisters all over her arms and neck and up her nose;
she hasn't been well since, and she's lost eighty pounds.

One time after dark, here come that cloud along,
Jeaney and me in it. I snapped pictures with my flash,
and they came back with millions of bubbles.

That proves something's venting, and the only thing vents
is a dehydrator. Come try it sometime, but you got to have a flash.

They say they're just pushing the gas along here,
but they're separating it.
Why else would you put a dehydrator here, buddy?

————————

It's just a constant sick now. Eight passed in this holla
in three years, and the ninth was my husband.
None of us was sick before this. He was born and raised here;
our daughter grew up playing in these fields.

That compressor, 250 feet from my home and hers,
is the only new thing. They put it in in 2005
and didn't even bother to get a permit until 2010.

A man come here and said he could get money for me
and Jeaney to move if we didn't tell the neighbors.
No, God wouldn't want me to do that, not with my neighbor
so sick and the ambulance coming for her all the time.

Now she's gone, they're both gone, and my grandkids
get the rash and tremors that come with this sickness.

————————

A quarter mile away, we've got Chevron wells,
another two miles, the Burnett compressor.
Compressors at Dunlap Creek and Shamrock.
Way too many compressors on the go in this county!

You know Wymps Gap, up Route 857?
My grandkids' father, his union was hired to pour concrete
for a wind turbine up there, and that ammonia smell
come up from the Burnett so strong,
they gave the men masks and special glasses.

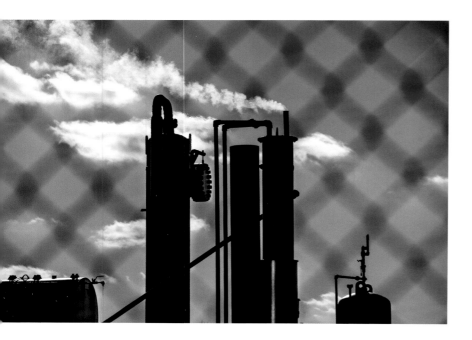

The governor made a law in 2011: if you live in a rural place,
it's Class 1, and they don't have to inspect your pipes and compressors.
It's gonna to take me another session with my counselor to get over that.

Hold on. There's no high-speed out here; we have dial-up,
so it takes a while, but I'll send you an article.

When a compressor exploded up north, federal inspectors showed up,
and the state told them to back off and move out. Class 1.
You'd think those people would say you're not going to kill us!

Other places—North Korea, China—they don't give a damn about their people,
but how can this happen here? So what if we're rural or poor—
I'm not poor—still, you have no right to poison our kids!

The industry bought our politicians, the only fighting tools
we had. And once your tools break down, you're done.

————————

My daughter and I don't cry around the kids.
We sit up at night when they're in bed.

A doctor said it's been too long for us. We won't ever get well.
These kids won't live out their lives, and they don't even know it.

But we have one tool the industry don't have,
and He's been watching over us. If it wasn't for God,
I'd a done shot myself this long time.

You get up on the mountain yourself and you'll see
a brown haze hanging over top of all of us.
Where will all the Uniontown people run
when that fog comes?

————————

The industry tries to make everyone think it's OK.
DEP makes me and Jeaney look like we're out of our heads.
Some EPA men came here and blamed the smells we get
on bobcat piss, wild flowers, burning trash!
Some of my own sisters won't believe me;
they say the officials would tell us if it was so dangerous.

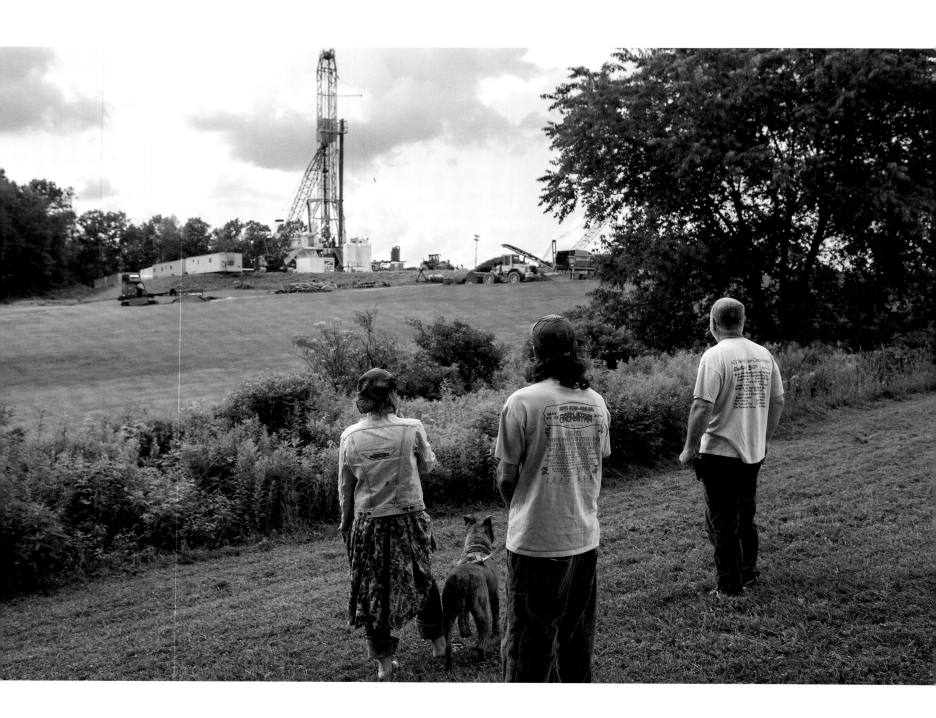

Sealed Record

You're both aware that in exchange for the sum of $750,000, you have given up all rights that you may have against all of the defendants in this case now and forever.

> Yes.

> Yes.

You understand that in exchange for that sum, you are required to turn over your home to the defendants in exchange for which you will be able to buy a new home?

> Yes.

> Yes.

Do you understand that by this agreement each of you has been subjected to a confidentiality agreement, which is, in essence, a gag order? You are not to comment in any fashion whatsoever about Marcellus Shale / fracking activities, and you accept that?

> Unfortunately, yes.

> Yes.

You both understand and accept that as written the settlement agreement may apply to your children's First Amendment rights as well?

> Yes.

> Yes.

And you accept that because you, as adults and as legal guardians and parents of these children, believe it is in the best interests of not only them but your family?

Yes, and health reasons. We needed to do this in order to get them out of this situation.

> Yes.

You understand, Stephanie, regardless of what may be said about you on the internet and blogs, you cannot respond and you will not respond?

> Yes.

Chris?

> Yes.

One last question. You understand that this record has also been requested to be sealed and that you have consented to it being sealed, which means that no one from this point forward will ever be able to review this record or have any understanding of what has happened here today?

> Yes.

> We have agreed to this because we needed to get the children out of there for their health and safety. My concern is they're minors. We know we're signing for silence forever, but how is this taking away our children's rights? I mean, my daughter is turning seven today, my son is ten.

Frankly, Your Honor, as an attorney, I don't know if it's possible to give up the First Amendment rights of a child. The defense has requested that be a part of the petition as worded. I will tell you we objected, but it was a take-it-or-leave-it situation. I have told them in an abundance of caution, and to protect my law firm, because I don't feel like having someone coming around when they turn eighteen and saying, "Look what you did to me."

Does defense counsel have any comment for the record?

> *The plaintiffs are defined as the whole family. That's the way the contract has been written. That's what we agreed to.*

Your Honor, as they have indicated, it is directed at the family, and these two minor children are part of the family. I have practiced thirty-some years. I've never seen a request like this, nor in my research, but they have made a choice, and . . .

So noted.

That's all I can say. And Chris, I don't have an answer for you or Stephanie other than what I've already told you.

Nor does the court have an answer for you, and I would agree with counsel that I don't know. That's a law school question, I guess.

> *Our position is that it does apply to the whole family. We would certainly enforce it.*

Right, and candidly, you as the parents are bound by it.

> If I may, no matter where we live, they're going to be among other children that are children of people in this industry, they're going to be around it every single day of their lives. If they say one of the illegal words when they're outside our guardianship, we're going to have difficulty controlling that. We can tell them they cannot say this, they cannot say that, but if on the playground . . .

So noted.

You will do, and you have accepted to do, the best you can as parents to prevent that from happening.

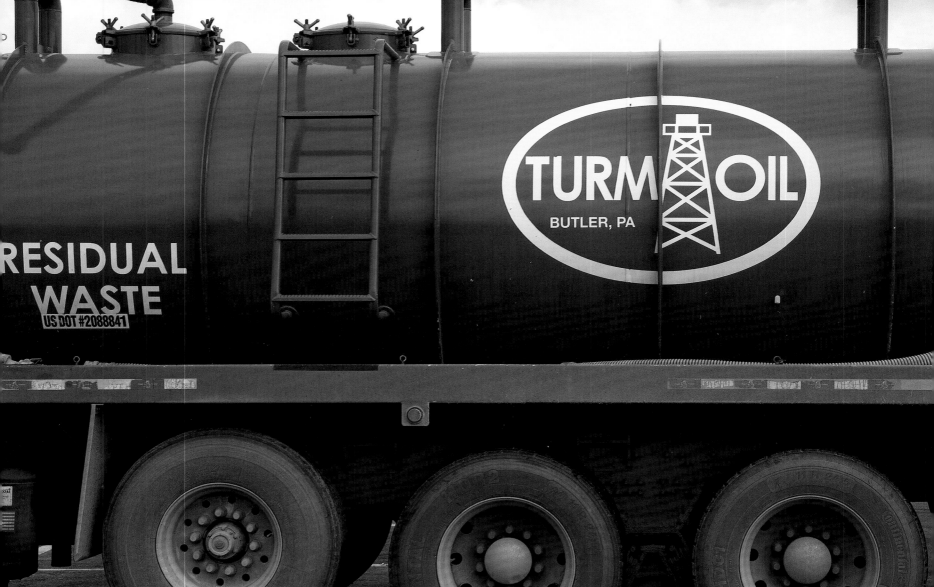

Hot Flash

I can be driving on a highway and it flies
across my face like flames over dry grass,

flares against the inside of my skin, scalds
the back of my eyes, so hot I could steam

the windshield, as when I pass another
tanker truck marked *Residual Waste*

—harmless as your kitchen trash, my eye!—
another flatbed hauling machine parts,

Halliburton in tiny letters on the driver's door,
or clean, white pickups with Texas plates

and no words at all. I can wake in sweat-dampened
T-shirts, plagued with complaints against myself:

faker, failure, bad mother or wife. I can be
chopping onions, talking to my kid, and I'm lit

like the Texas Eastern Transmission Pipe
in Edison, New Jersey. Pilots landing at Newark

saw an atomic bomb from the air, then
one-thousand-foot flames blazing in the night.

Fourteen apartment buildings destroyed,
lenses melted off the headlights of cars.

That was March 1994. I lived in Brooklyn,
just thirty-one and too far away to feel the blast.

CHEVRON
APPALACHIA, LLC
AUTHORIZED PERSONNEL ONLY

EMERGENCY # 724-564-3700

800 Mountain View Dr. • Smithfield, PA 154

NO TRESPASSING
NO SMOKING

At Jersey Mills, a Ridge Runner from Way Back Remembers the Wild Life

When my brother visits up here, he says, Let's run
in the mountains! When we were young, we'd sit
on a car window ledge and scream, Faster, Georgie, faster!,
speeding off Okome Mountain into Cedar Run. All of us
in that car are still living except the driver, Georgie.
Tiny dirt roads, now they've widened them with gravel,
packed them with big trucks so they look like highways.

One time I took him up there, they'd blocked the road
to the fire tower. Next time, the frackers were tearing it
down. They say they're concerned for our safety, of course.
They close roads for our safety, roads we've used all our lives,
and they put up security booths. Imagine needing security
on Okome Mountain! My three times great-grandfather,
Isaac Moore, an Irish seaman who came to the port
at Philadelphia, had a son who fired cannons in the Revolution;
then the 1790 census has him living over near English Center,
maybe working at the inn.

My great-grandfather, Nelson Moore, built a house
and barn up on Okome Mountain, kept a pasture and orchards.
Giant trees up there made the settlers think the land was good
for farming. There were enough folks living on top at one time
to support two schools, two places for mail. People just stayed
in the pioneer days a lot longer up there. At Beulah Land,
the most beautiful trailing arbutus used to grow along the road.
Now it's gone. I guess the trucks killed it.

When my great-grandfather went into lumbering,
he dragged logs off the mountain down to Pine Creek
and counted those of his concern here at Jersey Mills.
In spring and fall, the water was high enough to raft
logs down to the Susquehanna Boom at Williamsport.

I grew up in Williamsport, but I ran here all summer
with my cousins. Now we own much of Jersey Mills
on this side of Pine Creek. I tend the family cemetery
behind my cabin. Back then, we knew everyone
who swam the creek during the summer. We'd walk up to Cammal—
that's how some wood hick pronounced Campbell—
just to see what was going on. Nothing? Well then,
we'd put pennies on the rails. The New York Central
ran where the bike path goes now. Most of June we built
a diving board, which washed out every fall, of course.

At the end of the summer, kids stood on the porches
in Cammal and yelled, Goodbye, Flatlanders!
as vacationers drove by. They still come to hunt.
Halloween, we rammed sticks in the horns of hunters'
trucks parked at the bar, locked their doors, and ran!

Now when my cousins come, I drive them up to see
the wells and huge pipes coming out of the earth,
and enormous reservoirs. They're secretive
about where they draw water. They take it with pumps
and underground pipes. There's one at Tombs Run,

one on the Little Pine. This has not been a dry summer, yet
people wonder why the Little Pine is so low. I know why.
They draw it at Jersey Shore and up at Babb Creek in Morris.

Pine Creek is clean, but it is not a deep stream; our holes
are only four or five feet. In summer, it gets dangerously low
and warm. I've seen fish huddle at the mouth of Callahan Run.
We worry about our drinking water, too. It tests OK now,
but we don't know what to test for. The spring on 414,
where my cousin gets water, has started tasting like rust.

The other day, as I drove back from the food bank in Renovo—
I'd like to retire, but no one else wants to do the invoices—
up on the ridge across the creek near my grandfather's quarries—
(he moved off the mountain to cut flagstone;
they'd slide them down the ridge, cross the creek
in a stoneboat, and load them on a train at Jersey Mills)
I found they'd changed the roads so much up there,
I needed a GPS to find my way home. The only good
thing I saw that day was two bald eagles.

Last winter we heard them drilling on top of the mountain
every night, a low, constant rumble, and the animals
came down. It was bitter cold, but I think they were driven
by the noise and vibrations, all the trucks on the road
with those big grill guards in front so they can hit
a deer or bear and just keep going. I put out corn,
one hundred pounds every night; herds of deer and flocks
of turkey surrounded our cabin. The bear did not look healthy.

I think the frackers are uncomfortable among us, too.
They come from Texas, Oklahoma, Arkansas. They frequent
the Waterville Tavern and keep to themselves at the bar.
I guess it's redneck verses redneck. The gas stations
broadcast country western music at the pumps now.
We just don't buy as much gas as the other rednecks.

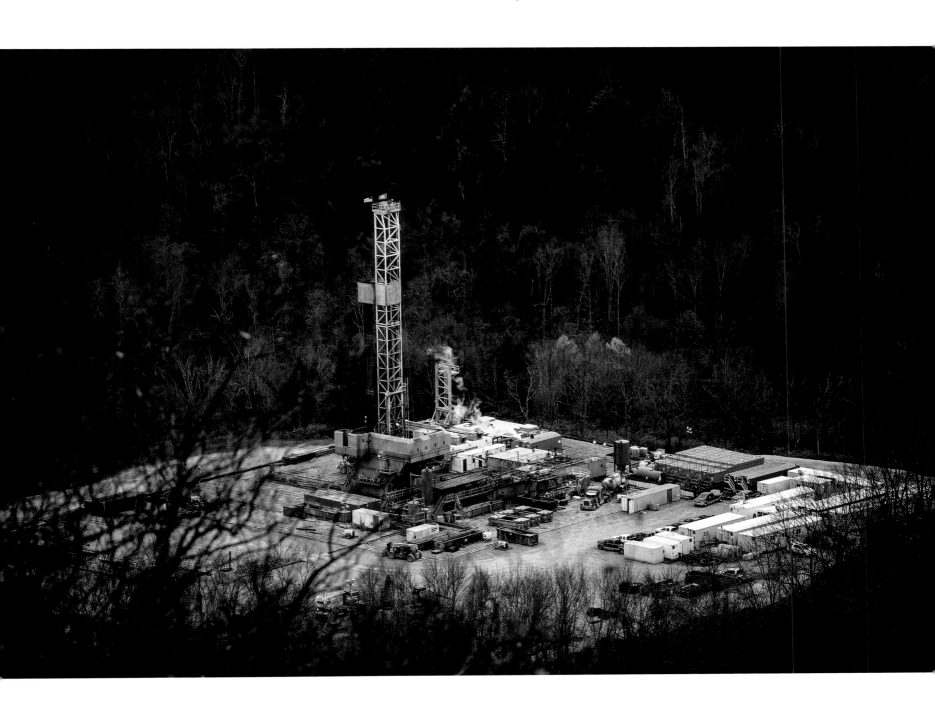

President of the Okome Conservation Club Returns from Reconstructive Surgery

If I'd have known what was coming, I never would have built
my log home. I've been coming up here since I was two.

This mountain was clear-cut in the nineteenth century—old-growth oak,
chestnut, maple—a 1,300-acre lumber camp. Early in the '50s,
when my grandparents started driving up from Lancaster,
the deer were just returning, brought in from Michigan.
We still feed them corn and hay, and we don't shoot doe.

About 80 percent of McHenry Township is state game land
or state forest, and we have 143—no, 141—voting residents.

Our roads are mainly dirt and gravel. When I was roadmaster,
we'd work on them every other week, clearing drains, filling holes.
When they were really drilling up here, Residual Waste trucks
would come up Truman Run and Old Post Office Roads, slopping
a goo out their hoses that looked and smelled like sewage.
As roadmaster, I cleaned the road, cleaned out the gutters.

Halliburton did the fracking up here, flatbed trucks hauled in
white cube containers with skull and crossbones.

I'm not the roadmaster anymore; I'm an occasional worker,
which means I plow snow.

And I look after camps for people. I used to take my dog along,
and back at the house, she'd lick and lick her paws. Pretty soon
a tumor grew in her jaw that became mouth and throat cancer.

I had Barley for ten years; putting her down was like killing
one of my own kids.

October of last year, a bump showed up on my forehead,
migrating toward my eyebrow. When the surgeon opened my head,
she found a mass that wasn't gristle; she didn't know what it was,
so they sent it off to the Mayo Clinic. The cancer is called DFSP
(dermatofibrosarcoma protuberans). They wouldn't touch it
in Williamsport—too close to my eye.

At the Fox Chase Cancer Center in Philadelphia,
a radiologist told me she had to pull her books out
when she saw my case come in, never dealt with anything
like it. They took pictures and asked hundreds of questions:
Did you ever wear a hard hat?
Yes.
What chemical did you get into while working?
No idea.

The tumor followed the pattern of the sweat band in my hard hat;
they think the toxins entered through sweat glands or tear ducts.

Surgeons scalped the front left side of my head—
nose and part of my cheek down to my left ear—
pulling out nerves from my face up into my hair.

To reconstruct my face, they took skin from my left arm—
meat and all—elbow to my wrist, and an artery.

The perfect skin for an eyelid comes from right here
on your clavicle.

I know a guy who manned a booth for Gas Well Security
on the road up here, and he got really, really sick,
something in his lungs. We had contaminated liquids
on these roads, now we have contaminated dust,
so I wear a mask and don't let this dog walk on the gravel.

White pines grow like dandelions up here, but our trees
were already stressed with acid rain; now the needles
turn yellow when they start to die from the air pollution.

This area used to be full of laurel.

Where the retention ponds are, we had highbush blueberries—
everyone came up here and picked them. We had two
European chestnuts, but the drillers took both of them down
when they widened the road.

Drilling has slowed down now, but infrastructure—
compressor sites and pipelines—that's the new game on our hill.

How can they call this *The Pennsylvania Wilds*?
If you get lost up here now, you ought to be ashamed.

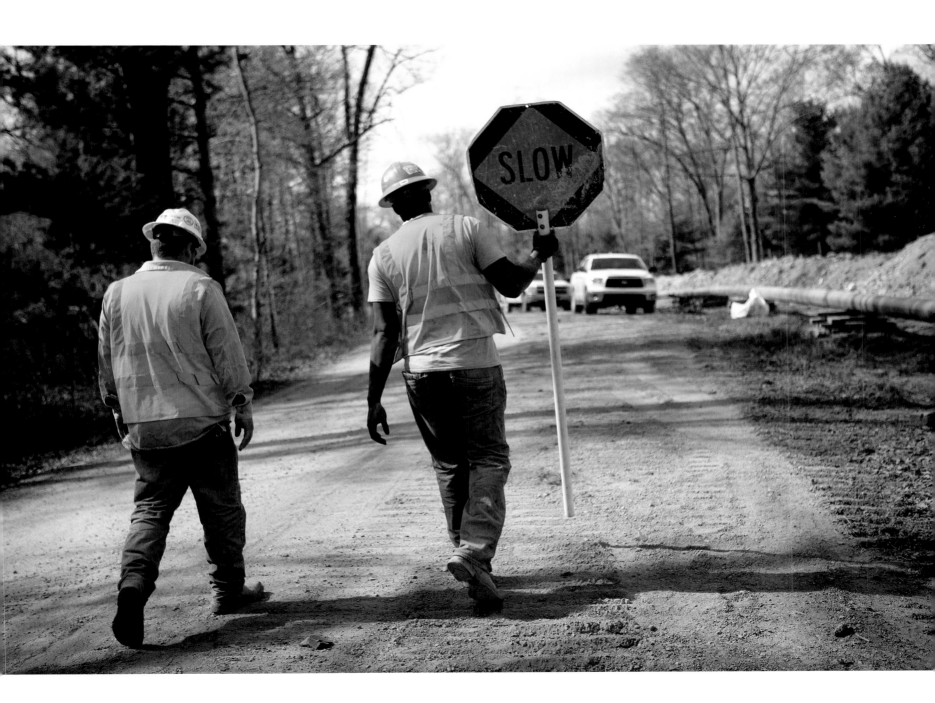

In the Tiadaghton State Forest, a Man with a Clipboard Stands Beside Men Welding Pipes Made in Korea

We're not the gas company; we just lay the pipeline.
I make sure the pipe's good, the joints are welded right.
This is twelve-inch, to connect those wells to a compressor.
The pipeline that exploded in western Pennsylvania
was thirty-inch; they're laying up to forty-eight-inch pipes now.

I grew up in Nebraska, but I own land in West Virginia.
Most of these guys are from Texas, Georgia, Oklahoma.
I was in the military seven years—Japan, Korea, Kuwait,
Qatar, Mississippi—I've moved around a lot, and I like that.
I've laid pipe in Tioga, Waynesburg, Scranton, Wyomissing.
I go to Iowa next. Some of these guys will go to Oklahoma;
some will go up to North Dakota.

Every one of these guys is divorced once or twice.
I'm divorced, but I have a girlfriend now; this is my first trip out.
I said let's just see how it goes. I know I can't work 9 to 5—
I tried it. I just can't walk through that same door every day.

This is not an easy job. If it was easy, they'd have women
and children up here. I've been on jobs where we got shot at
in Michigan, in West Virginia. A man didn't want a pipeline
on his land—I understand that. He fought it and lost, so.

I see these protesters, and every one of them drives
up to the site in a car. I don't make my own clothes,
do you? They all come from China or someplace else.
Did you come up here on a horse? I wish there was
some other way. I could make a living as a welder,
but for now, this is the best job I can get.

Take care out here. You don't have reflective gear
or hard hats. Steer clear of the guy at the end;
he's got the X-ray. Don't want you getting filled up
with radiation.

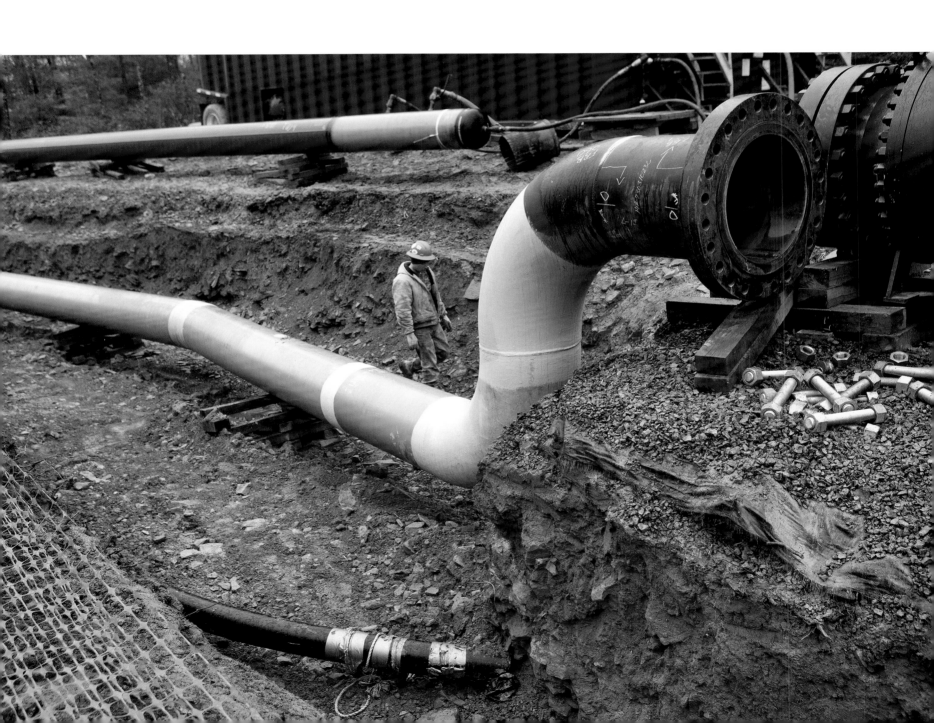

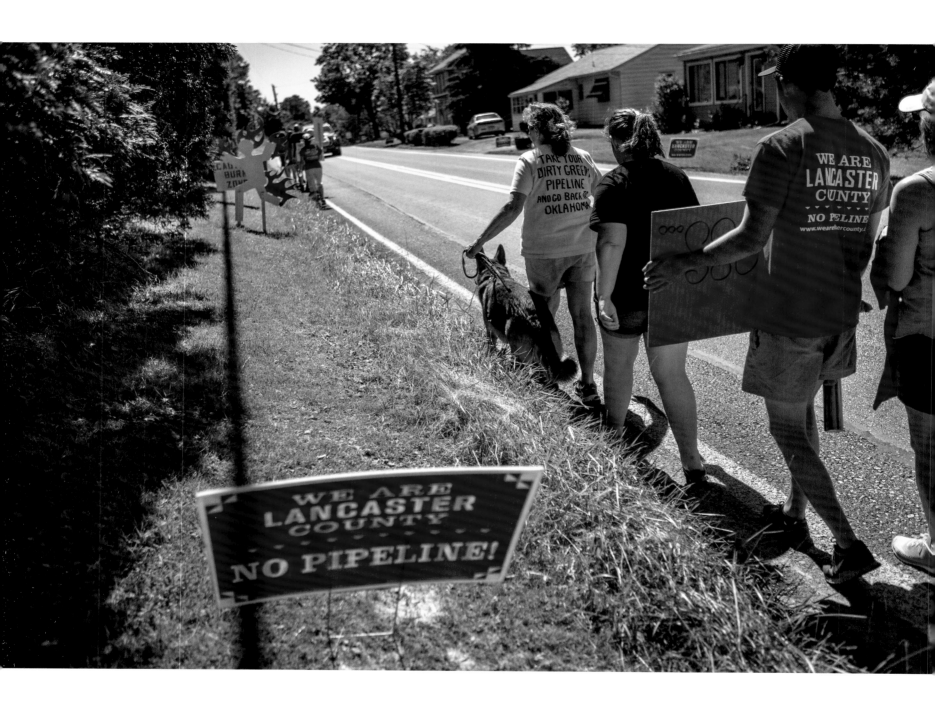

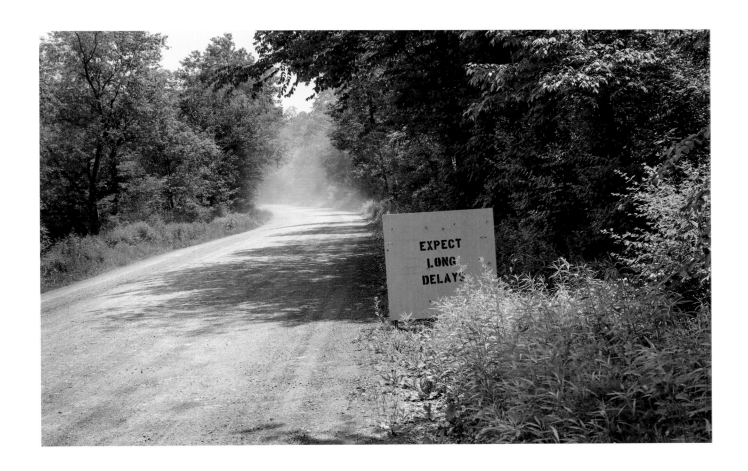

Sacrifice Zone, Tioga County, PA

These are the roads to take when you think of your country, dirt
roads where men lift a finger from the steering wheel and nod.

Along Caitlin Hollow, paved by Shell as a service to the
 community,
I stop to photograph a barn, and a guy slows, opens his window,

asks if I need help. At the Tioga County Historical Society
the docent says they never sent the same landman twice.

They'd say, Your neighbor leased, so why don't you?
But my neighbor said, Hell no, he told me you leased!

They said if we don't lease, they'd take our gas anyway.
Some learned they didn't own the rights to their land

or a lease from the '30s still applied; some got two grand
an acre, some twenty bucks; some just got dirt and noise.

Hay bales stacked along a back road block truck headlights
from shining into their bedroom windows. Figure

it takes four thousand runs for each well. A rig can sit outside
a guy's kitchen, and the poor soul won't see a cent.

During the Great Depression, everyone was broke, but
in Wellsboro gas streetlamps glowed and royalties built

new homes. In '38, the Corning plant silvered the inside
of Christmas balls, hired extra hands just to cap and pack.

In '46, workers made an American flag of 1,438 balls
for a party in the Penn Wells Hotel. It still hangs in the lobby.

What would you do with a million bucks—with ten?
They let us watch them frack our land as long

as we wore fireproof suits, a house cleaner says.
Four months, our home covered with gritty mud,

and they never stop drilling except a few days
at Christmas. Our neighbor's well burned as loud

as jets taking off, seven days. They said if we let them
drill, we'll be free of Arab oil for a hundred years,

then they turn around and sell our gas to foreigners.
At this rate, it will be gone in ten. On the Wellsboro Green,

see the statue of a dreamy boy with a rifle:
In Memory of the Soldiers and Sailors of Tioga Co.

Who died that the Nation Might Live, 1861–1865.
At 660 and Route 6, see Shell Appalachia, Multi-Chem,

a water impoundment, scores of red tankers. *These
are the roads to take when you think of your country*.

I live by a pond where they drew water, the docent says.
Night and day, trucks screeched their brakes, then

a pothole grew as wide as this hallway. Every day
I drive my little car into that hole, cross, scrape out.

See gravel well pads, gathering lines, compressor stations.
See hay standing late in the fields. With all this rain,

it won't be worth more than three dollars a bale. Cultivators
rust in farm yards; a cast-iron pot froths pink petunias.

Wood derricks burst into flame along Pine Creek, 1890s,
and oil flooded the stream. You hear of people writing

checks for a quarter million dollars to the IRS, and see
all the farms up for sale? Why bother to paint or cut hay;
they'll hang on to the mineral rights and move away
before their water wells go bad. In Tioga County,

only three people were ever hanged for murder:
1885, George Travis killed Martha Sylvia;

1898, Walter Goodwin shot his estranged wife;
1900, Isaac Birriolo set fire to his wife's skirts,

then held her hands so she could not save herself.
The founder of Mansfield's grower's market wakes

to flames flashing on the bedroom wallpaper,
but it's just her neighbor's gas well flaring off.

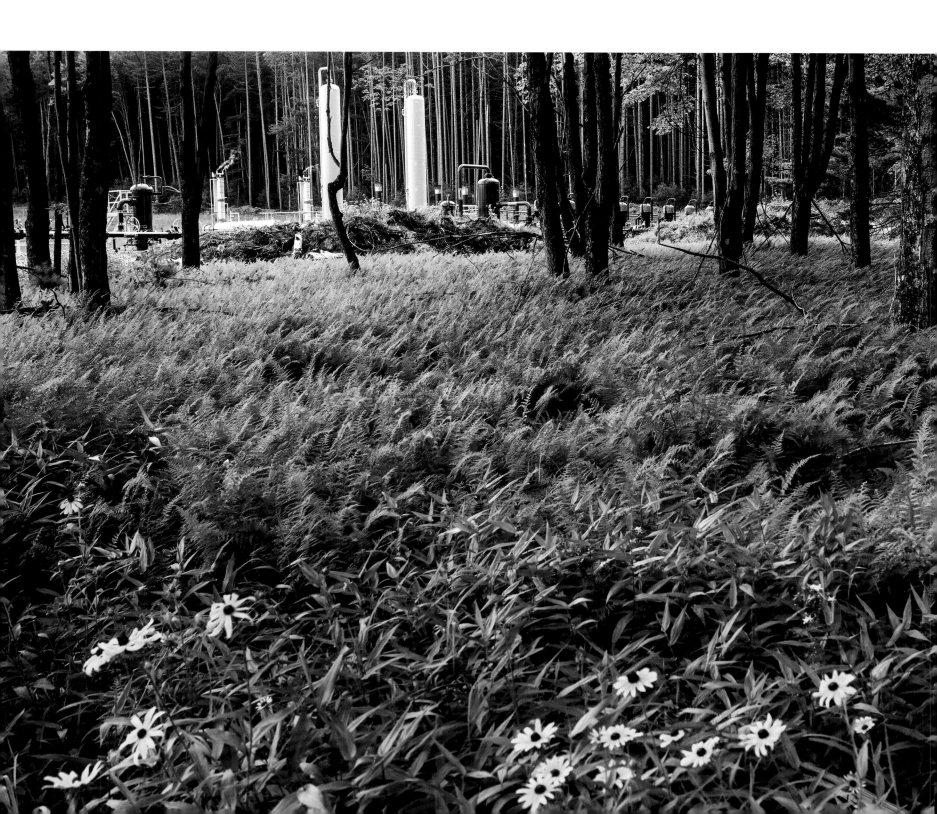

A Student from Tunkhannock Articulates Shale Gas Aspirations

Unfolds her silver laptop to a Google Earth view of a forested ridge:
I grew up in the hundred-acre wood. Now it's my screen saver.
My parents negotiated a $300,000 lease, paid
their debts, then divorced. We were the horse that bit the carrot.

They'd say, royalties will pay for college, your grandchildren's
college! We'll get thirty thousand a month when they drill!
In those kinds of places, you're raised to leave, and college
is the way out. If you stay, you work at Burger King and get fat.

So many kids from my high school are at Slippery Rock now,
farthest place from Tunkhannock they could get into and afford
to pay for with lease money. When Penn State calculates
my financial aid, the parental contribution comes up zero.

I'll be $37,000 in debt when I graduate,
and the gas company didn't renew our lease last year.
My mom called them up, but once you ask, you're fucked.
Full time at Firestone Complete Auto Care, she can't make enough

to pay tax on the land. She'll have to sell what kept us going
back then. Anytime we saw a big truck on the road, we'd say,
Look, they're here! We're going to be rich!
Once, driving along the Susquehanna, we saw white pipes

sticking out of the mud, and we knew they'd finally come.
We watched, waited. Or we said maybe if we give up,
they'll come. Those were soil conservation pipes for planting trees!
The gas company clear-cut a ninety-foot-wide right-of-way

through our woods. We made sure they reinforced the road
so their trucks won't crush the pipeline if they ever
drill on our land. They paid us forty thousand for that.
I can't go back there now. Who wants to see the place

you shot your first deer or had your first sex, where
you drank your first beer turned into a gravel pit?
We just wanted to get out from under, to start over. I spent
my growing up hoping, waiting, knowing we'd been taken.

Now Tunkhannock has a Hampton Inn and a Super Walmart.
Some small businesses closed, or they hang on to spite it.
Everyone feels the land getting ruined, and the families, too.
You know how clannish these places are; now they're mad

because guys from Texas date the girls, but they won't talk
about that. Everyone knows what gas trucks look like now,
what happens when they stop and spread out some stones.

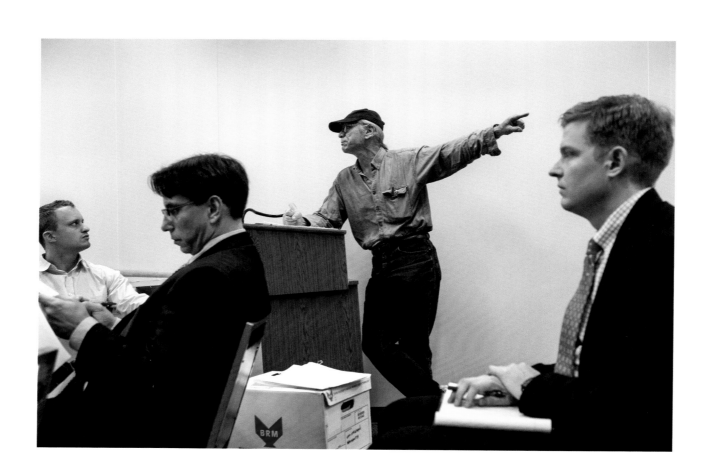

Notes from the Zoning Hearing Board re Springhill #2 Compressor Station, German Township, Fayette County, Zoned A-1, Agricultural Rural

ZHB10-20R, continued from
September 14, 2014

April 22, 2015

Attorney in a bespoke suit and smart haircut questions the supervisor of operations,
who speaks with a drawl and wears a plaid shirt, jeans, and thick-heeled cowboy boots:

How many employees does Williams have in Connellsville?
 Sixty-five.
And are most of these people from Oklahoma or Texas?
 No.
How many are assigned to the compressor site?
 Twelve or fourteen.
How many compressors does Laurel Mountain Midstream have?
 Sixteen.
How many local wells does it serve?
 One thousand.
How many miles of shallow gathering lines?
 One hundred.
What are the factors in locating compressor stations?
 They want a rural setting as close as possible to the wells, as close as possible
 to the Federal Energy Regulatory Commission transmission pipeline.
How much did Atlas spend to build this compressor station in 2005?
 At least a million dollars.
How much did Laurel Mountain Midstream spend to improve it?
 Seven hundred thousand is a conservative estimate.

As of 2010, Laurel Mountain Midstream has been aware
it needed a permit and special exception for this facility.
We received zoning, but the board approved it subject to conditions.

We want to be responsible.
We want to be good neighbors.
We have long-term plans for Fayette County.
Williams has been around for one hundred years,
and we intend to be here a long time.

————————

To speak, you have to be sworn in.
To speak, you must have standing.
To have standing, you must be a person aggrieved who owns property
that abuts the compressor station.
You may speak as a party in opposition if you live within half a mile.

Attorney for Mountain Watershed,
which has twelve hundred members in this region,
requests that the board go out to view the site.
The board refuses.

————————

Stan Burns, retired high school band director, recorded sounds within a half mile of the site.
 At the edge of my yard, I hear a rather loud rumbling continuously,
 twenty-four hours a day; it began in 2012.
 I made a recording with my iPhone of the sound.

So, these noises we are going to hear have not been substantiated by an expert?
You're a band leader; that makes you an expert in the tuba, Mr. Burns, says a board member.

 We hear a loud squealing sound that happens at an intermediate level,
 goes up high, then shuts off.
 When I had my grandkids on a Saturday, it went on all day.
 A squeal, like if you took a balloon, stretched the neck, and let the air escape.

Do you know why the compressor station makes this noise? asks the attorney
for the aggrieved party.

>No. That's why I'm here. I've asked before.
>We're dealing with an inherent explosive close to our home.
>I have asked before, and no one wants to offer an explanation.

April 13, 2016

Gray flames and white clouds churn from the compressor station stacks,
billow, and drift again and again across the screen.

Looks like steam, says a board member.

>No, the FLIR thermographer captures invisible hydrocarbon emissions,
>says the attorney for the aggrieved party.

Objection. This falls under the jurisdiction of the DEP, not this Zoning Hearing Board.

Who took these pictures?
Did you take those pictures?
We need an expert to explain what we're looking at, says a board member.

I am not going to look at that! I'm not looking. Another board member
covers her eyes with her hand.

>Listen, lady, you better look. We have to live with it! Stan Burns's wife, Jean,
>white hair perfectly permed, pressed pink blouse, slowly rises to her feet,
>voice trembling.

Sheriff in a bulletproof vest runs into the room and calls the meeting to order,
pistols snug at his hips.

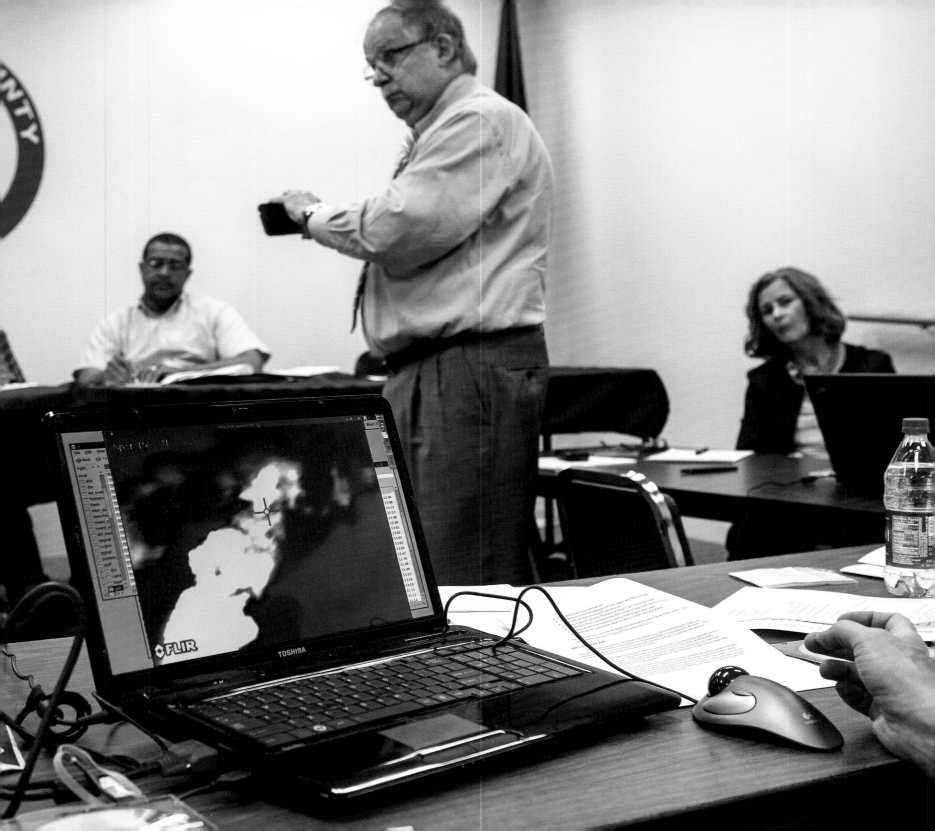

———

I don't need no expert to tell me this community is suffering.
The Vietnam vet with a silver ponytail, who mined coal
and worked at the Clairton coke plant, raises a hand. He shows an appraisal
to prove devaluation of his home, also within a half mile.

May 25, 2016

 Exhibit 4 was a noise study by a certified expert. Exhibit 5 is a video . . .

We have a standing objection to all of this, interrupts the attorney in a bespoke suit.
Air-related issues are not relevant to this hearing.

 This FLIR video captures emissions coming from the new dehydrator,
 says the attorney for the aggrieved party.

We object on relevance grounds, says the attorney in a bespoke suit. If we're done
with the video, can we turn it off?

 Sharon Louise Wilson, certified in optical gas imaging, drives a highway in Louisiana
 while raising her right hand to swear in by phone. The emission appears to be steam,
 but it may not be steam entirely. It may contain volatile organic compounds.
 Most of the time steam dissipates quickly; I couldn't be absolutely sure
 without having it tested. It does appear that emissions are traveling off-site
 into the surrounding community.

Objection.

 I had to take the video standing outside the fence line,
 and I can say with confidence that emissions are traveling to surrounding areas.

Objection on relevance grounds.
Have you reviewed the Laurel Mountain Midstream air permit?
These emissions are in compliance with state standards.

 I am telling you emissions are traveling across the fence line to the surrounding area,
 and the community believes they are being affected by them.

Objection on relevance.

————

 Sometimes it smelled like someone dumped a bucket of turpentine on our porch,
 says a man who lives within a half mile.

 What is a safe distance? Ask that man running for his life after the pipeline exploded up there in Delmont, says another neighbor.

————

 The DEP is so understaffed, they cannot make regular inspections, says Cowboy Boots.
 We are required to do our own FLIR testing and to report our own leaks.

————

This hearing will continue at our next scheduled meeting after a discussion of the proposed methadone clinic in Uniontown.

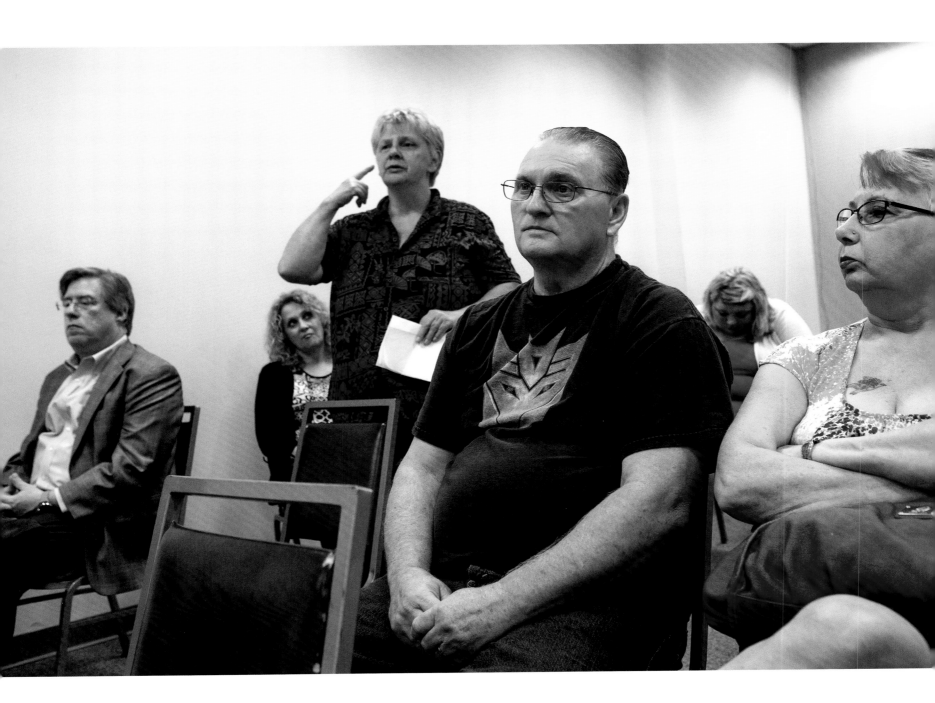

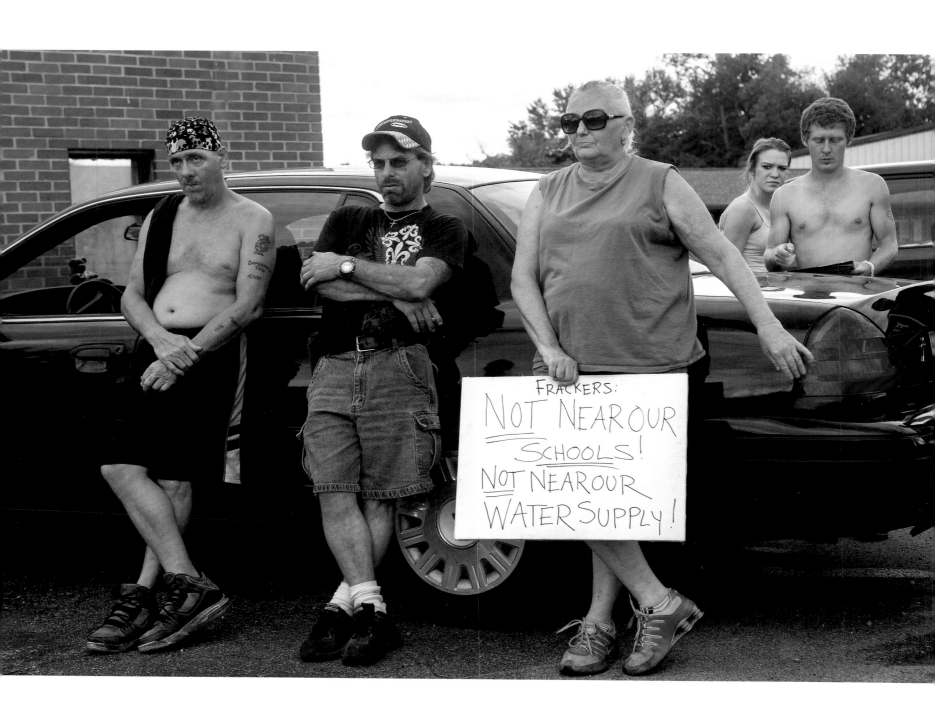

What This Picture Can't Tell You

That the car, purchased for a bargain according to the man in the black shirt, was built for cops, it's so fast.

That for more than a century, almost everyone here worked at Houze Glass, which among other things made one hundred trays that Richard Nixon presented on his diplomatic mission to China in 1972. The factory closed in 2004.

That on a nearby building, a mosaic of sparkly glass shards depicts an albino deer that once appeared here, at the confluence of the Cheat and Monongahela Rivers.

That the walk was organized in solidarity with Hands Across Our Land to protest the impacts of fracking and pipeline construction, according to Duane, whose great-great-grandfather grew up across the river in Greene County. Duane now lives on Cheat Lake.

That the signs we all carried across the Mon and back that morning Duane had used in other natural gas demonstrations.

That as a grad student, he was a white guy who helped to integrate fifty restaurants in Delaware and nearly lost his federal fellowship in chemical engineering.

That some of his friends in sleek bicycle attire also joined the march, having ridden up from West Virginia on a trail that once was a railroad.

That the woman on the right gathered the other guys and carefully chose the sign she holds.

That crossing the bridge, Veronica told me she'd spent the summer delivering rain barrels to people whose water wells had been fouled by acid mine drainage in Greene County. Rain's not safe to drink, but you can use it to wash and bathe.

That as walkers traversed the turquoise steel expanse, natural gas pickups passed, and one coal truck honked. The man on the left told me he truly does not like the idea of anyone dynamiting mountains to lay a pipeline then ducked behind his sign.

That an interpretive panel with an etching depicting two ferries and the ornate nineteenth-century facades of Point Marion was removed
 from the bridge
and presumably sold for scrap metal, prompting someone to joke, That's why they call it Steeler Country.

That 23.5 percent of families in Point Marion Borough now live below the poverty line.

That when we returned, Duane presented each walker with a twenty-dollar bill and shrugged, What else would I do with it?

That the young couple signing the petition on the car trunk would not carry signs across the bridge and back for cash.

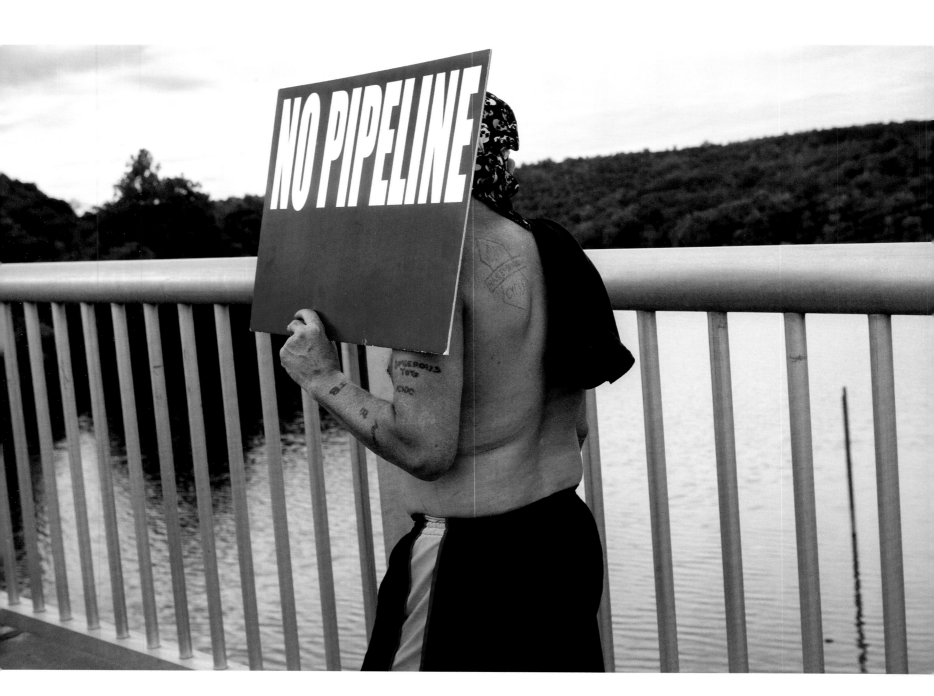

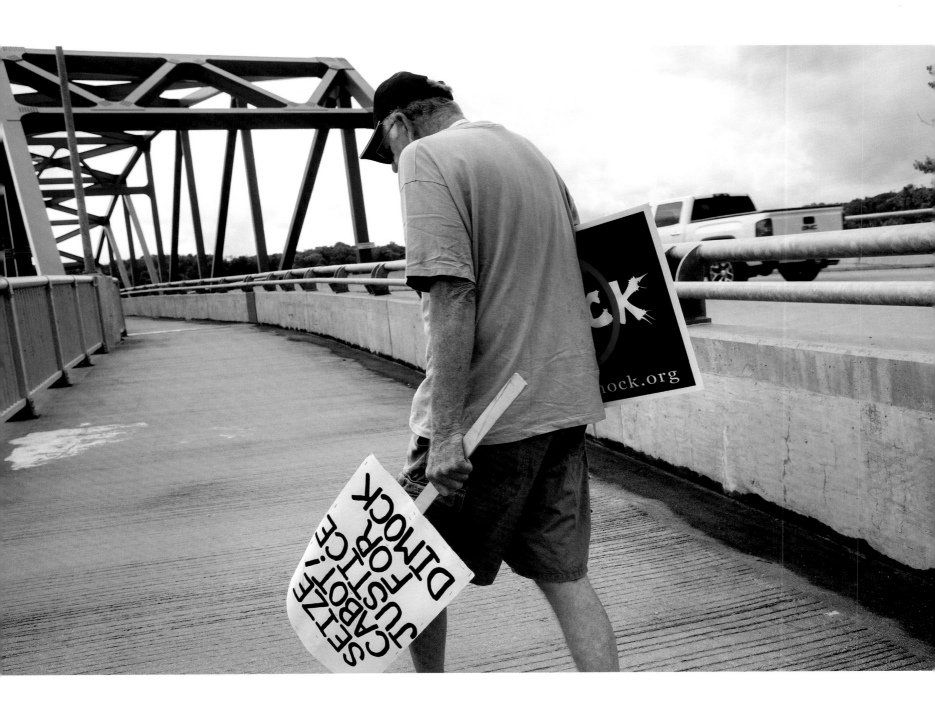

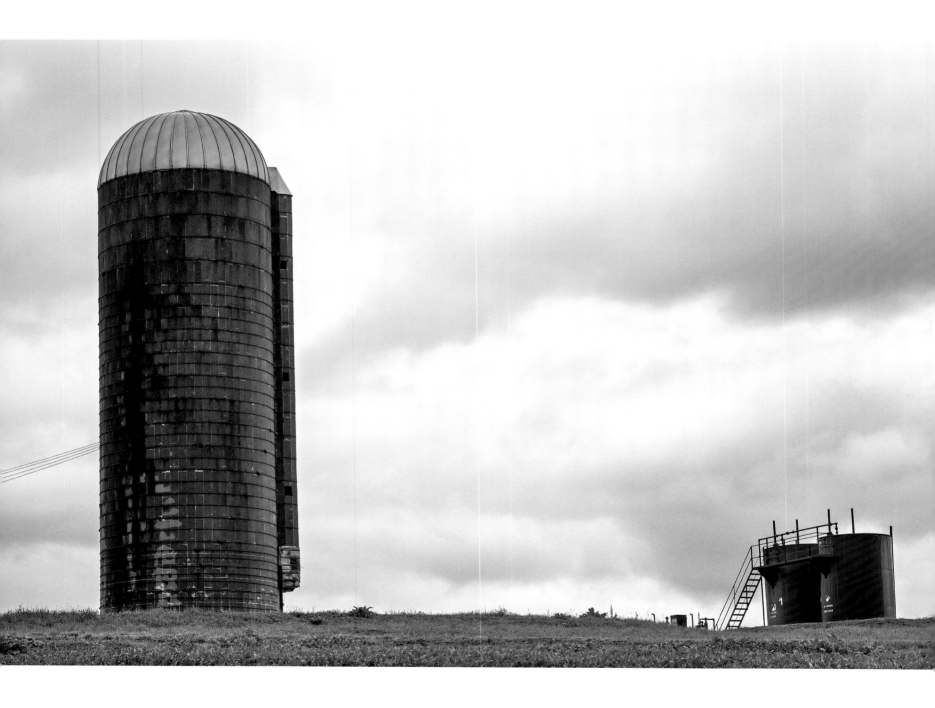

Among Landowners and Industrial Stakeholders, the Citizen with Too Much Memory Seeks Standing to Speak of Recent Events in Penn's Woods

When I drive south on I-78, diagonal highway from New York to Harrisburg,
the Blue Mountain presses my right shoulder for miles, dividing coal tipples from hex signs
on barns, French and Indian territory from the British colony. At Shartlesville,
in the parking lot of Roadside America, a giant Amish couple on a spring wagon marks
my ancestors' settlement at Northkill, the Hochstetler cabin, torched in 1757.

After the fire, Lenape and Shawnee warriors marched Jacob and two of his sons for seventeen days
to the French Fort at Erie. Seven months later, Jacob escaped, walked nine nights and days
through forest, eating grass. At the Susquehanna, he lashed logs with grapevines
and floated south for four days until British soldiers fished him out, nearly dead,
at Fort Augusta or Shamokin, now Sunbury, corporate headquarters of Weis Markets.

Growing up, we knew the Hochstetlers had guns but would not shoot; the warriors killed
Jacob's wife, whose name no one recalls, because she refused to share fruit with them.
When we misbehaved, Dad threatened to give us back to the Indians. We didn't know
that Christian Hochstetler kept running back to his captors after he was returned
to his father. We didn't know that Barbara Kauffman grabbed an ax and hacked
the fingers of an Indian man as he tried to climb through her cabin window.
He ran screaming into the forest.

Penn's surveyors carved initials into the trunks of great trees—white oak, black oak,
red oak, hickory, and walnut—sighted a compass from the trunk of the corner tree,
and stretched iron measuring chains to make boundaries. Corner trees they called
witness trees. When Shikellamy ruled the refugees at Shamokin, he implored the Lenape,
Seneca, and Tutelo to grow corn, squash, and beans but to refrain from planting apples
and peaches for fear they would create a plantation.

During the French and Indian War, braves from the Forks of the Ohio, now Pittsburgh,
attacked six European families near a trading post on Penns Creek, slaying fourteen and
capturing twenty-eight, among them the wife and children of Jacob Beyerly. A woman was found
with a chain draped around her neck, a man with a tomahawk, freshly inscribed
with English initials, sunk in his skull like a log. Bierly is the name of the lawyer
who filed papers for my divorce.

About to swing his ax into a tree, Hannes Miller—three of his children married
Speichers—was shot by an Indian. He was called Wounded Hannes, Crippled John, or
Indian John until his death in Somerset. Some insist they can hear old trees shriek
the instant an ax hits. The Northkill Amish moved west, seeking more and better land.
I live near fields some of them farmed.

By the 1850s, ridges around here were bare, trees baked into charcoal to fuel the iron furnaces.
In 1955, my father, driving a feed truck for Belleville Flour Mills, lost his brakes
on Nittany Ridge. He shifted down, laid on the horn, flew off Centre Hall Mountain, thick
with hemlock and rhododendron, and blared through Pleasant Gap without incident.

In the ten miles I drive to work, I pass three prisons. The oldest opened in 1915, the year
M. G. Brumbaugh became the last ordained pacifist governor of Pennsylvania.
At Rockview, called the Honor Farm, inmates learned to prune apple trees and tend
a Victorian glasshouse. I have seen guards on horseback beside dark-skinned prisoners
swinging scythes in the ditch along Benner Pike.

In 1939, my great-grandfather was killed by a tree that fell the wrong way
when he was logging on Jack's Mountain. Around that time, the Klan in Pleasant Gap
prevented white Catholics from building a high school in Bellefonte.

Behind Rockview prison, in a copse of hemlocks at the foot of the Nittany Ridge,
an electric chair sits in a former field hospital. By the year I was born, the state had electrocuted
350 people there. Since then, three more have died by lethal injection.
The Dunkers never forgave Governor Brumbaugh for calling the National Guard to shoot
strikers in Pittsburgh or for calling the Pennsylvania militia to arms during the First World War.

In fifth and sixth grades, on the way to Manor School I climbed a black wooden overpass
that spanned the main line of the Pennsylvania Railroad. Some mornings I stopped
and stood in the wind roaring above hopper cars heaped with coal and iron pellets
bound for mills along the rivers in Pittsburgh, and imagined flight.

At the end of Peight's Lane, not far from where a horse-and-buggy accident killed
my grandmother in 1948, I spied a Texas Eastern Transmission sign.
This aluminum-sided shed is party to the fourth largest natural gas line in the nation,
which runs from the Gulf of Mexico to New York City. How did that pipe snake
in over Jack's Mountain without my knowledge?

When they clear-cut the right-of-way to lay pipeline over the Nittany Ridge in 2009,
gasmen left good lumber to rot, my handyman says. The Centre Relay Compressor Station
stands on a former cornfield in Pleasant Gap. The pipe runs past Weis Market, recently built
on a razed farm, and ends in gas storage fields at Leidy, under the Tamarack Swamp.
I, who have never eaten grass out of necessity, drive home and cook my groceries
on a gas stove.

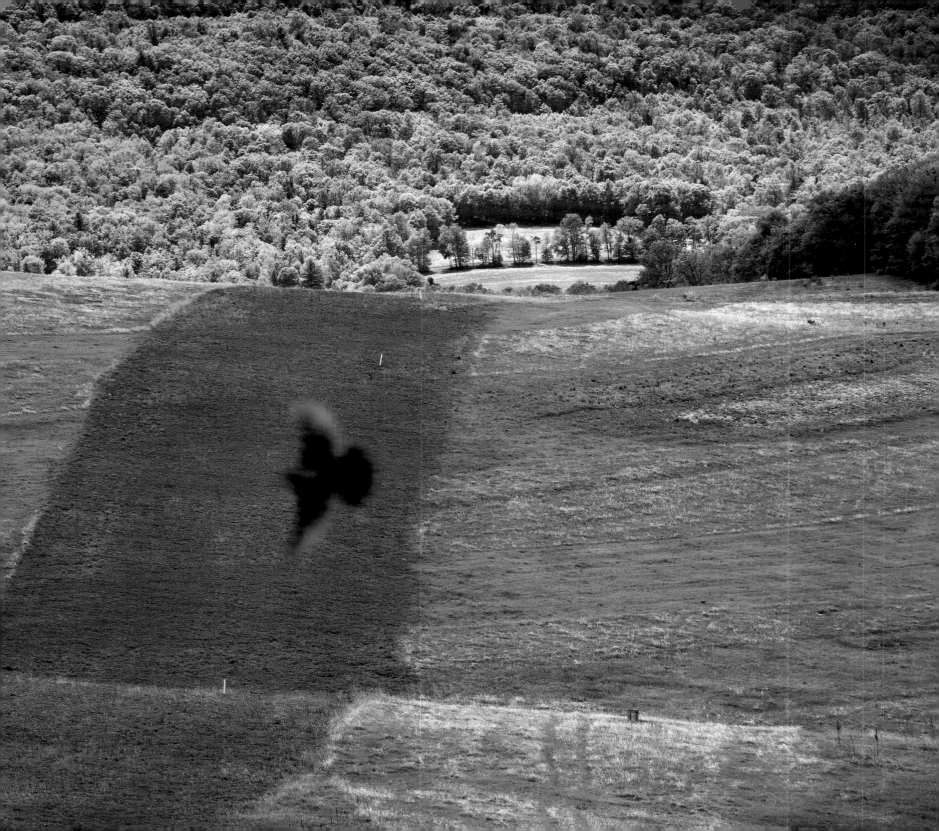

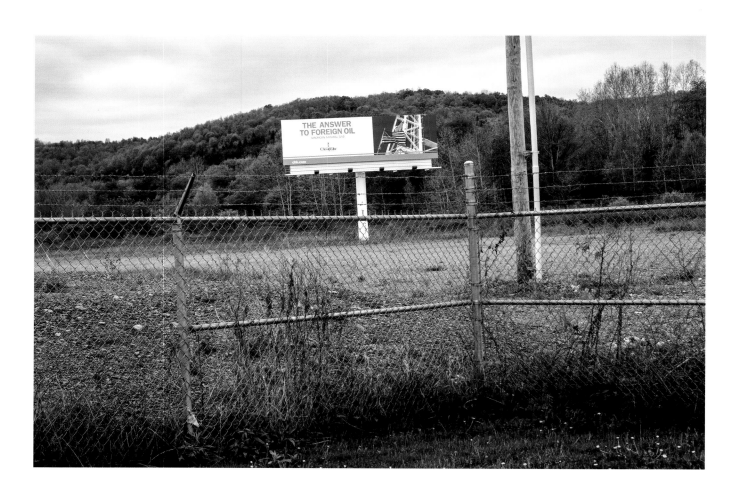

Notes

Preface

In addition to the cited sources, the preface was informed by several books that chronicle the development of unconventional and horizontal drilling in Texas and Pennsylvania: Russell Gold's *The Boom: How Fracking Ignited the American Energy Revolution and Changed the World* (New York: Simon and Schuster, 2014); Seamus McGraw's *The End of Country* (New York: Random House, 2011); and Tom Wilber's *Under the Surface: Fracking, Fortunes, and the Fate of the Marcellus Shale* (Ithaca, N.Y.: Cornell University Press, 2012). Helpful in understanding the economics and language that underlie conventional patterns of extraction and exploitation in our state are: Bill Conlogue's *Here and There: Reading Pennsylvania's Working Landscapes* (University Park: Penn State University Press, 2013), James Guignard's *Pedaling the Sacrifice Zone: Teaching, Writing, and Living Above the Marcellus Shale* (College Station: Texas A&M University Press, 2015); and Rob Nixon's *Slow Violence and the Environmentalism of the Poor* (Cambridge, Mass.: Harvard University Press, 2011). For maps, data, and more immediate news stories, we also consulted the websites of StateImpact Pennsylvania, National Public Radio's reporting project focused on shale gas development in Pennsylvania; MCOR, Penn State's Marcellus Center for Outreach and Research; and the U.S. Energy Information Service. p. xv

Gathering Lines

Gathering lines is a term that refers to the small pipelines that deliver gas from wells to compressor stations and transmission lines. Some quoted material in this poem was drawn directly from road signs and websites. Newspaper reports of the Mammoth Mine Disaster come from "As a Thief in the Night Black Death Steals into the Frick Company's Mammoth Mines and Strews 60 Acres with Corpses," *Mount Pleasant Journal*, February 3, 1891, and "Over a Hundred Killed: A Disastrous Explosion of Fire-Damp / Miners Suffocated in the Mammoth Shaft of the Frick Coke Company—Sixty Bodies Recovered and the Mine on Fire," *New York Times*, January 28, 1891, http://patheoldminer .rootsweb.ancestry.com/mammoth.html. p. 29

Letter from Mrs. Lois Bainbridge to Governor Duff

"Letter from Mrs. Lois Bainbridge to Governor Duff" is the text of a two-page letter handwritten in blue fountain pen ink on paper held in the Pennsylvania State Archives, Manuscript Group 190: James H. Duff Papers, http://explorepahistory.com /odocument.php?docId=1-4-2B9. p. 43

St. Nicholas of Donora, PA

"St. Nicholas of Donora, PA" quotes Syrian maxims that appear in the poem "Better than Beauty" by Eliot Khalil Wilson, in *The Saint of Letting Small Fish Go* (Cleveland: Cleveland State University Poetry Center, 2003). p. 45

Sealed Record

"Sealed Record" quotes the transcript of sealed, in-chambers proceedings before Honorable Paul Pozonsky, judge, August 23, 2011, Court of Common Pleas of Washington County, PA, Civil Division. Stephanie Hallowich and Chris Hallowich, plaintiffs. Range Resources Corporation; Williams / Laurel Mountain Midstream; Markwest Energy Partners, LP; Markwest Energy Group, LLC; and PA Dept. of Environmental Protection, defendants. The *Pittsburgh Post-Gazette* and the *Observer Reporter* filed petitions to intervene and motions to unseal the transcript, and in January 2013, Judge Debbie O'Dell Seneca unsealed the transcript on the grounds that corporations do not have the same rights to privacy as individuals. p. 55

Sacrifice Zone, Tioga County, PA

"Sacrifice Zone" is dedicated to Jimmy Guignard and Lilace Mellin Guignard. The refrain "These are the roads to take when you think of your country" quotes Muriel Rukeyser's poem "The Road," from the sequence *The Book of the Dead*, published in 1938 and now available in *The Collected Poems of Muriel Rukeyser* (Pittsburgh: University of Pittsburgh Press, 2006). p. 75

Notes from the Zoning Hearing Board re Springhill #2 Compressor Station, German Township, Fayette County, Zoned A-1, Agricultural Rural

"Notes from the Zoning Hearing Board re Springhill #2 Compressor Station, German Township, Fayette County, Zoned A-1, Agricultural Rural" follows a series of meetings that eventually concluded in the Zoning Hearing Board overruling the objections of the Laurel Mountain Midstream lawyer. Consequently, the citizens of Springhill Township did obtain a condition pertaining to air pollution in the special exception; this represents the first time in Fayette County history that consideration of air pollution has influenced this kind of decision. p. 83

Among Landowners and Industrial Stakeholders, the Citizen with Too Much Memory Seeks Standing to Speak of Recent Events in Penn's Woods

"Among Landowners and Industrial Stakeholders, the Citizen with Too Much Memory Seeks Standing to Speak of Recent Events in Penn's Woods" is factual, to the best of my knowledge, except that my father's feed truck lost its brakes driving off Tussey Mountain into Stone Valley, instead of Mount Nittany into Nittany Valley. p. 95

Photograph Captions

p. i

A large capacity fracking tank holds flowback water during a fracking operation at the Inflection Energy well pad in Eldred Township, Lycoming County, Pennsylvania. The Department of Environmental Protection has cited Inflection Energy for repeated violations at this site, including the company's failure to properly cement gas wells, and for spilling approximately 63,000 gallons of flowback fluid, which discharged into a nearby tributary to Loyalsock Creek. All of the nearby residents rely on private water wells for their water supply. September 18, 2016

p. ii

A resident of Conestoga and her dog head off to join a march against the construction of the Atlantic Sunrise pipeline, a 42-inch-diameter natural gas pipeline that will cut through the township in Lancaster County, Pennsylvania. June 12, 2016

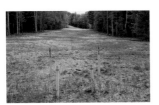

p. iii

Buried gas pipeline along Route 287, near Salladasburg in Lycoming County, Pennsylvania. When cutting through forestland, pipelines can contribute to forest fragmentation, resulting in the introduction of invasive species and decreased biodiversity. May 13, 2015

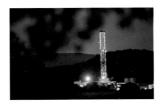

p. iv

Illuminated drilling rig operated by Swepi, an affiliate of Royal Dutch Shell, along McKissick Road in Delmar Township near Wellsboro, Tioga County, Pennsylvania. August 15, 2015

p. xiv

Drilling rig operated by XTO Energy at a well pad next to the Summit Elementary School playground in Butler, Butler County, Pennsylvania. A growing number of epidemiological studies note a correlation between the proximity of shale gas operations and detrimental health effects suffered by children and other especially vulnerable populations. July 2, 2015

p. xvi

Oil tank at the Action Oil Company location in Dunbar, Fayette County, Pennsylvania. A report tracing the use of various heating fuels by the U.S. Census Bureau, Housing and Household Economics Statistics Division, shows in 1940, 86.2 percent of Pennsylvania households used coal or coke for heat; 5.9 percent used fuel oil or kerosene, and 4.4 percent used utility gas. By 2000, 1.4 percent of Pennsylvania homes heated with coal or coke; 25.5 percent used fuel oil or kerosene, and 51.3 percent used utility gas. November 14, 2015

p. xxx

Pro-industry billboard along Interstate 80 near the town of Mackeyville in Clinton County, Pennsylvania. November 23, 2015

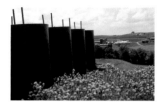

p. xxx

Gas condensate tanks adjoining gas wells on the Jackson dairy farm in New Salem, outside of Uniontown in Fayette County, Pennsylvania. June 30, 2014 p. xxx

p. xxx

Water pumped from the Youghiogheny River is sold outside a Keystone Gas Solutions company warehouse in Smithton, Westmoreland County, Pennsylvania. An estimated 4.5 million gallons of water is used in each fracked well in the Marcellus Shale of Pennsylvania, according to a 2012 United States Geological Survey. June 29, 2015

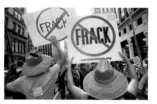

p. xxx

Protesters during the Stop the Frack Attack march, the first ever national protest against fracking in Washington, D.C. During the march, demonstrators delivered jugs of toxic fracking waste water to the headquarters of the American Petroleum Institute and America's Natural Gas Alliance. July 28, 2012

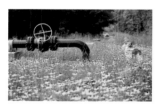

p. xxx

A gas company pickup truck approaches the control valve of a gas pipeline inside Tiadaghton State Forest, Lycoming County, Pennsylvania. Nearly one-third of Pennsylvania's approximately two million acres of public forest land is available for oil and gas development. July 21, 2014

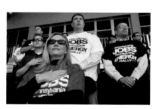

p. xxx

Participants in the Pennsylvania Jobs, Pennsylvania Energy march and rally organized by the Marcellus Shale Coalition, an industry-sponsored pro-drilling event in Harrisburg, Pennsylvania. Several thousand workers from across the state came to show support for the industry, oppose a severance tax, and champion the benefits that shale development has brought to the Commonwealth and the region. May 6, 2014

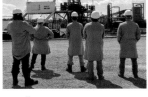

p. xxvii

Laid-off workers and students training for a variety of shale gas careers with ShaleNET, a federally funded workforce development program at Westmoreland County Community College, visit a Marcellus Shale drilling rig in Greene County, Pennsylvania. On the last day of their course, students were invited on this tour to get a close-up view of the rig. August 23, 2012

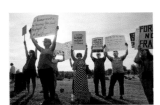

p. xxix

Anti-fracking activists protest Governor Corbett's visit to the annual Memorial Day celebration in Boalsburg, Centre County, Pennsylvania. Three days before, late in the afternoon on the Friday of Memorial Day weekend, the governor issued an executive order to allow natural gas drilling under state parks and forests, overturning a 2010 state moratorium on new oil and gas leasing of public park and forest land. May 26, 2014

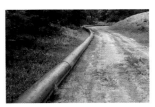

p. 2

Water pipeline leading to a fracking site in Moshannon State Forest, Clearfield County, Pennsylvania. The use of large quantities of water for fracking raises concerns about the multiple ecological impacts, including threats to aquatic life and drinking water supplies. July 12, 2012

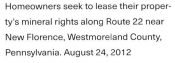
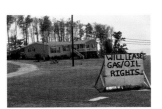

p. 4

Homeowners seek to lease their property's mineral rights along Route 22 near New Florence, Westmoreland County, Pennsylvania. August 24, 2012

p. 6 (detail)

Copies of old photographs on display in the waiting area at the Fry Brothers Turkey Ranch restaurant in Trout Run, Lycoming County, Pennsylvania. November 5, 2016

p. 7

Sign referencing Psalm 46:10 outside the Steam Valley Bible Church along Route 184 in Trout Run, Lycoming County, Pennsylvania. November 5, 2016

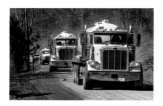

p. 8

Water trucks arrive at an Anadarko drill pad site, Pine Township, Lycoming County, Pennsylvania. The transportation of several million gallons of water (whether fresh or produced water) to frack a well can require hundreds of truck trips, clogging rural roads and increasing the greenhouse gas footprint of oil and gas production. April 12, 2014

p. 11

Laid off with the industry's downturn after five years working for Halliburton, a worker gets retrained in the Roustabout certification program at Pennsylvania College of Technology's Energy Technology Education Center in Montgomery, Lycoming County, Pennsylvania. October 9, 2015

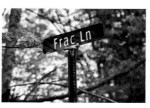

p. 13

Frac Lane street sign in Charleston Township in Tioga County, Pennsylvania. A Shell Appalachia well pad with multiple code violations is located at the end of the lane. May 12, 2015

p. 14

The view from a neighbor's backyard—a fracking operation at the Inflection Energy well site on Yeagle Road in Eldred Township, Lycoming County, Pennsylvania. September 18, 2016

A natural gas wellhead and control valve on a family's farm in Springhill Township in Fayette County, Pennsylvania. June 30, 2015

p. 15

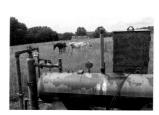

p. 17

Horses graze near a home and gas separator and well pad in Springhill Township in Fayette County, Pennsylvania. The residents own the land but not the gas rights and ended up with five gas wells (four shallow and one Marcellus) on their property. Two wells are located in the front yard, less than five hundred feet from their house. June 30, 2015

p. 19

Bubbles of methane gas float to the surface in a family's spring in Springhill Township in Fayette County, Pennsylvania. The family's horses stopped drinking from the spring after it began to bubble. The bubbles appeared soon after gas drilling started nearby. June 30, 2015

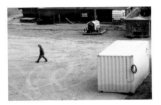

p. 20

Gas worker strides across the well pad during the drilling phase at an Inflection Energy site in Eldred Township, Lycoming County, Pennsylvania. November 15, 2014

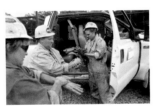

p. 22

Women workers clean up after a day spent spray-painting green paint on gas well pads throughout Moshannon State Forest in Clearfield County, Pennsylvania. July 12, 2012

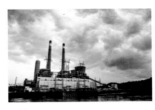

p. 23

Hatfield's Ferry coal-fired power plant on the west bank of the Monongahela River in Greene County, Pennsylvania, near the borough of Masontown. The plant was deactivated in late 2013 by FirstEnergy Corporation, citing the cost of compliance with federal regulations on the emissions of lead, mercury, arsenic, and other fine particles. June 30, 2015

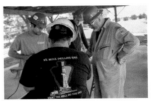

p. 24

Students and laid-off workers receive training in the Roustabout certification program at Pennsylvania College of Technology's Energy Technology Education Center in Montgomery, Lycoming County, Pennsylvania. Rex Moore, right, a fourth-generation oil field worker, is the director of training and instructor with the Shale Training and Education Center (ShaleTEC), a collaboration between Pennsylvania College of Technology and Penn State Extension, with support from the Department of Labor. October 12, 2015

p. 26

Anthony Maiolie mows the lawn near an Apex Energy drilling operation in Penn Township, Westmoreland County, Pennsylvania. June 29, 2015

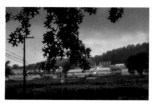

p. 27

The Delmont Compressor Station in Delmont, Westmoreland County, Pennsylvania. Part of the natural gas transmission system along the Texas Eastern Pipeline, the station sits over a depleted gas field, now one of the country's largest underground natural gas storage facilities. October 21, 2016

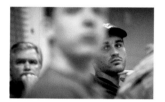

p. 28

Listening to a presentation by gas company personnel, students train for a variety of shale gas careers with ShaleNET, a federally funded workforce development program at Westmoreland County Community College in Youngwood, Westmoreland County, Pennsylvania. August 23, 2012

p. 31

Coke ovens near the community of Shoaf in Fayette County, Pennsylvania. The community was first established between 1903 and 1905 by H. C. Frick & Company, and in 1972 Shoaf was among the last beehive coke yards in the nation to close because it could not comply with clean air standards. November 13, 2015

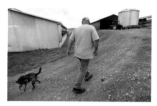

p. 32

Bill Jackson, a dairy farmer with multiple shale gas wells on his family's nine-hundred-acre farm in New Salem, outside of Uniontown in Fayette County, Pennsylvania. He acknowledges the benefits gained from lease money he receives from the gas company, which has allowed him to make improvements to his farm, including the purchase of a new tractor and harvester. June 30, 2014

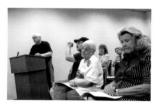

p. 33

Joe Bezjak, a retired schoolteacher and principal at Point Marion Junior High School, challenges the Fayette County Commissioners to refrain from leasing German-Masontown Park to Chevron Corporation for Marcellus shale gas drilling. Bezjak said he has been dealing with oil and gas people since 2002, and he has nothing good to say about them or their procedures. His comments took place during the Fayette County Commissioners meeting in Uniontown, Fayette County, Pennsylvania. August 18, 2015

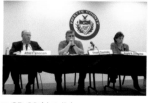

p. 35–36 (details)

Commissioner Alfred Ambrosini, Chairman Vincent Zapotosky, and Commissioner Angela Zimmerlink listen to the testimony of citizens during a public comment period during a Fayette County Commissioners meeting in Uniontown, Fayette County, Pennsylvania. The meeting concerned the commissioners' decision to lease German-Masontown Park to Chevron Corporation for Marcellus shale gas drilling. August 18, 2015

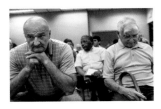

p. 37

Citizens attend a public comment period concerning the Fayette County Commissioners' decision to lease German-Masontown Park to Chevron Corporation for Marcellus shale gas drilling, during the Fayette County Commissioners meeting, Uniontown, Fayette County, Pennsylvania. August 18, 2015

p. 38

The Shamrock Compressor Station with nearby residences in German Township near New Salem, Fayette County, Pennsylvania. Built by Laurel Mountain Midstream, a joint venture between Chevron Corporation and the Williams Companies, Shamrock is a large gas compression and dehydration facility permitted in 2010. Connected to the Texas Eastern Pipeline, the 215-acre site includes four miles of pipeline, metering, and storage tanks. November 14, 2015

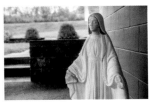

p. 41

A statue of the Blessed Mother outside a home that sits directly across New Salem Road from the Shamrock Compressor Station in German Township near New Salem, Fayette County, Pennsylvania. October 21, 2016

p. 42

Street scene in Donora, Washington County, Pennsylvania, once the industrial hub of the Mid-Monongahela River Valley. June 29, 2015

p. 44

Closed storefront along McKean Avenue, the main thoroughfare in Donora, Washington County, Pennsylvania. July 21, 2015

p. 47

Jim DeShong, an itinerant worker and single dad, carries his two daughters on his lawn mower while traveling from job to job in Donora, Washington County, Pennsylvania. His health problems, including a bad hip and right shoulder, prompted his doctor to advise him to slow down. "But how can I do that," he asks, "with two young girls?" July 21, 2015

p. 48

Colby Perrotta, a math teacher in a nearby high school, visits the site of the Donora-Webster Bridge along the Monongahela River with his four-year-old daughter in Donora, Washington County, Pennsylvania. The 107-year-old truss bridge was demolished due to its deteriorated condition. Repair or replacement options were considered too costly. July 2, 2015

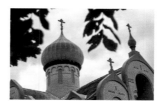

p. 49

St. Nicholas Orthodox Church in Donora, Washington County, Pennsylvania. This place of worship was built in Russian Orthodox style in 1951 on the foundation of a smaller chapel erected in 1918. July 2, 2015

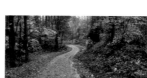
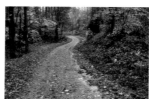

p. 50

Hope Hollow Road in Lake Lynn, Fayette County, Pennsylvania. October 21, 2016

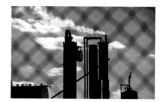

p. 52

Emissions from the Springhill #2 Compressor Station in Lake Lynn, Fayette County, Pennsylvania. November 14, 2015

p. 53

Residence along Hope Hollow Road near the Springhill #2 Compressor Station in Lake Lynn, Fayette County, Pennsylvania. October 21, 2016

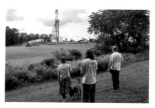

p. 54

Michael Badges-Canning, a climate activist and retired schoolteacher (right), with Chad Santee and Penni Laine, concerned mother and neighbor of Summit Elementary School, where a nearby drilling rig is seen a short distance from the school's playgrounds and lawn. The well is the Kozik Brothers' well and is operated by XTO Energy in Summit Township, Butler County, Pennsylvania. July 2, 2015

p. 57

Driveway leading up to the Hallowich house in Mount Pleasant Township, Washington County, Pennsylvania. Now owned by Range Resources as part of a settlement deal, the house was subsequently leased to an employee of the company. August 28, 2016

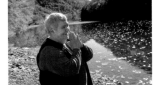

p. 62

Dee Calhoun, a retired schoolteacher and Episcopal priest, along Pine Creek in Jersey Mills, Lycoming County, Pennsylvania. October 23, 2015

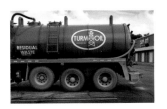

p. 58

Residual Waste truck parked outside the Park Inn, Uniontown, Fayette County, Pennsylvania. July 21, 2015

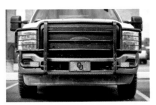

p. 64

Oklahoma University plate on a gas industry pickup outside a hotel in Uniontown, Fayette County, Pennsylvania. August 18, 2015

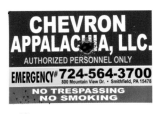

p. 60

Shot-up signage belonging to Chevron Appalachia in Snow Shoe Township in Centre County, Pennsylvania. June 11, 2015

p. 65

Drilling rig at an Inflection Energy well pad site along Yeagle Road in Eldred Township, Lycoming County, Pennsylvania. The horizontal drilling extends under nearby Rider Park, an 867-acre tract of land where a sign at the park's entrance proclaims "an area preserved for people to enjoy nature." November 15, 2014

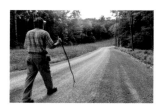

Bob Deering walks along what was once a narrow mountain road in Tiadaghton State Forest in Lycoming County, Pennsylvania. July 17, 2014

p. 67

p. 68

A breathing mask hangs from the rearview mirror of Bob Deering's pickup truck while driving through Tiadaghton State Forest, Lycoming County, Pennsylvania. Healthy all his life, he developed a slew of serious health conditions, including cancer, after working on the roads during widespread drilling operations in the state forest. July 17, 2014

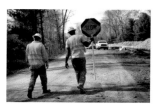

Pipeline construction workers inside Tiadaghton State Forest near Waterville, Lycoming County, Pennsylvania. The twelve-inch pipeline they are laying will connect nearby well pads to a new compressor station inside the state forest. May 12, 2016

p. 69

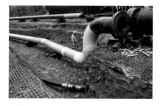

Worker assisting in the pressure test of a new gas pipeline inside Tiadaghton State Forest, Lycoming County, Pennsylvania. April 4, 2014

p. 71

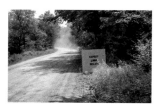

Participants in a protest and march against the Atlantic Sunrise pipeline in Conestoga, Lancaster County, Pennsylvania. June 12, 2016

p. 72

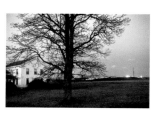

Backcountry road during pipeline construction in Snow Shoe Township, Centre County, Pennsylvania. June 11, 2015

p. 73

Farmhouse beside a drilling site on Spencer Road on the outskirts of Mansfield, Tioga County, Pennsylvania. November 24, 2014

p. 74

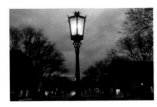

p. 76

Gas-powered streetlamps along Main Street in Wellsboro, Tioga County, Pennsylvania. May 13, 2015

p. 77

A truck related to gas industry activity passes by a statue honoring war veterans inside The Green, the town square in Wellsboro, Tioga County, Pennsylvania. May 13, 2015

p. 78

Separators and other gas-processing components on a well pad inside Tiadaghton State Forest, Lycoming County, Pennsylvania. July 17, 2014

p. 81

Land cleared for the construction of additional gas industry infrastructure in Tiadaghton State Forest, Lycoming County, Pennsylvania. Deforestation contributes to climate change, while the segmentation of forests leaves the adjoining forest lands vulnerable to biodiversity loss. November 24, 2014

p. 82

John Ryeczek testifies about the many problems of living close to the Springhill #2 Compressor Station during a meeting of the Zoning Hearing Board in Uniontown, Fayette County, Pennsylvania. The operations supervisor at the compressor station and corporate lawyers representing the Williams gas company sit nearby. May 25, 2016

p. 85–86 (detail)

An attorney airs FLIR video footage showing emissions coming from the Springhill #2 Compressor Station during a meeting of the Zoning Hearing Board in Uniontown, Fayette County, Pennsylvania. May 25, 2016

During the public comment portion of the Zoning Hearing Board meeting in Uniontown, Phyllis Carr describes the harm she and her family have experienced from living so close to the Springhill #2 Compressor Station in Fayette County, Pennsylvania. May 25, 2016

p. 89

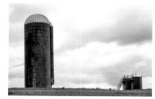

Farm silo and Chevron gas condensate tanks on the Honsaker Farm in Masontown, German Township, Fayette County, Pennsylvania. August 18, 2015

p. 94

Residents of Point Marion in Fayette County, Pennsylvania, at one of many region-wide Hands Across Our Land protests called to protect the land and communities from the unnecessary building of new natural gas infrastructure, such as pipelines. August 18, 2015

p. 90

Buried gas and water pipelines extend underneath farmland near Route 973 in Watson Township, Lycoming County, Pennsylvania. May 13, 2015

p. 99

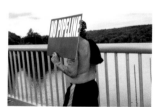

Anti-pipeline protester walks on the Point Marion Bridge and over the Monongahela River in Point Marion, Fayette County, Pennsylvania. August 18, 2015

p. 92

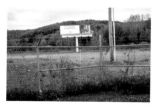

A Chesapeake Energy billboard proclaims, "The Answer to Foreign Oil—American Natural Gas" in an empty laydown yard in Mansfield, Tioga County, Pennsylvania. The site was filled with drilling equipment during the fracking boom in 2011. May 13, 2015

p. 100

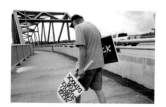

Duane Nichols of Frack Check West Virginia walks across the Point Marion Bridge following an anti-pipeline protest in Point Marion in Fayette County, Pennsylvania. August 18, 2015

p. 93